RELEASING JEZEBEL

EMBRACING THE LIONESS WITHIN

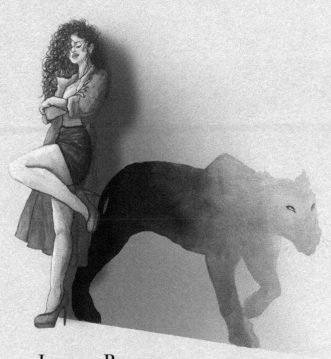

JENELLE BREWER

This debut novel tells a very personal, raw, and honest account of the effects of abuse and addiction. Jenelle's storytelling ability provides a riveting tale of how she was able to work through her years of trauma to become a mother, university graduate, and community leader. A must-read!

Rachel Jenkins BSW

My cousin's story shows the reality of intergenerational effects of colonialism. Her sharing of childhood experiences and how they shaped her ensuing adulthood choices are a profound example of sharing, vulnerability and reclamation that is needed in our communities at this time. In the aftermath of residential schools, the midst of colonialism, and forward-looking to reconciliation, the work of examining our individual relationship to intergenerational effects of colonialism should be done by each of us.

Dallas Good Water

This book is a must-read, not only for anyone who has experienced personal addiction and trauma but for those who have dealt with loved ones or friends in the throes of it. It is insightful, very raw, and truly heartbreaking. It shows the vulnerability of our youth and how quickly innocence can be stolen right out from underneath, even the most watchful eyes. It gives a real sense of how easy it is to fall into a place that most don't come back from. I admire the author for exposing her innermost layers in order to help others....and for becoming the woman she is today.

Nikki Brown

Releasing Jezebel

Embracing the Lioness Within

Jenelle Brewer

Daring to Share Global

Published by Jenelle Brewer

April 2023 ISBN: 9781738843909

Copyright © 2023 by Jenelle Brewer

Editor: Diana Reyers
Typesetter: Greg Salisbury
Book Cover: Olli Vidal

Note to the Reader

This book contains themes around
Abuse, Addiction, and Trauma.

Names and identifying details have been changed to
protect the privacy of individuals.

Dedication

For those who have supported my journey in recovery:

First and foremost, to my kids, Draigan and Renée, you are two amazing humans who had to share every step of my journey with me, and I am so grateful that you continue to stand beside me making me strive to be a better person every day.

To my late mum and dad, you gave me all the love and support I needed so I could still be here with you today.

To Dr. Stephen Friesen, you stepped up and gave me a chance when no other doctor would—you saved my life.

To Constable Doug Robinson, you also saved my life by taking a moment to help me see the person I forgot I wanted to be.

Testimonials

Jenelle is a warrior and a survivor. Releasing Jezebel Embracing the Lion Within is a powerful immersion into the often-unpredictable exhaustion of addiction and the uncontrolled chaos of trauma survival. Jenelle's toxic journey leading to self-actualization is a testament to core inner strength; the power to take control of the chaos and calmly, powerfully chart the path to defining one's self.

Rachael Zubick

I was very moved when I read Jenelle's story because it instantly captivated me, and I could not stop reading it! I have known her for about ten years. During that time, she graduated from my yoga teacher training and continues to practice and teach yoga at my studio. I know her to be very grounded, smart, and spiritual. Jenelle is a beautiful person with a big heart who impresses me with her accomplishments and contributions to our community. Until I read her memoir, I did not know the extent of the childhood trauma she suffered or the hard life she lived in her youth. Amazingly, she survived and recovered from both the trauma and addictions that took over her life. Her incredibly inspiring account gives hope to those who have gone or are still going through similar hardships. This is a real eye-opener for those who have never had to experience something similar.

Lea (Elara) Reardon
Certified Yoga Teacher
Inner Light Yoga and Wellness

Jenelle has overcome so much adversity—she transformed her anger from abuse and addiction into positive energy, giving back to her community through work and volunteering. To courageously and rawly expose herself to the public and risk potential judgement with the intention of helping others is immense and inspiring. I have only known Jenelle as the fierce, determined, and confident woman she is today. After reading her book, I am truly in awe of her hard work and inner strength. Her commitment to aid, inspire, and support those in need is something we can all be grateful for and aspire to be as a result of knowing this amazing Fierce Lioness.

Linnea Faherty

Jenelle is definitely the full package—beautiful inside and out, smart, quick-witted, and funny as hell. As a strong woman, she can look after herself, perhaps because she's had to or because she won't let anyone help her! Jenelle is full of common sense, and when it comes to work, she follows all the rules as a policy maker. With a cool demeanor, she can fearlessly speak in the largest rooms and makes it look easy. She is someone I can tell my deepest secrets to without feeling judged. Jenelle humbly worries about the unfortunate and genuinely does what she can to help others without seeking praise. As a community supporter, whether within her band, her town, or another community she is associated with, she advocates for all. She expresses her immense love for family and friends in the big and little ways she supports and spoils them. I could go on forever, but I will end with the words I started with—Jenelle Brewer is the full package!

Tetku Marchand

Wow! I cried, got upset, was hurt and angry!! However, by the end, a little light of hope filled my heart! This is a beautifully written book by Jenelle. Her story will magically transport you to all the incredibly hard but true-life moments that shaped her to be the incredibly empowered woman she is today! Perseverance, determination, and hope are a few adjectives that came to mind when reading about her journey. Jenelle, you are truly an inspiration! Thank you for being vulnerable; I know it wasn't easy. Thank you for being fierce and strong as a great role model others look up to. But most importantly, thank you for being a true light in this world while showing us that with willingness, change can happen!

Angie Ioakimidou

Jenelle Brewer's important memoir brings to the forefront the devastating effects of complex issues that indigenous women are facing and have faced in their lives. Her raw story is heartbreaking as she spirals downwards into addiction from a young age and becomes a victim of sexual violence and sex trafficking. As I read her story, my heart ached as I shed some tears for both her pain and how I related personally to parts of what she went through. After reaching rock bottom, Jenelle began the long path to healing and to her truth. I have known her personally for several years, and her will to educate herself, raise her children, and volunteer to help those still caught in the cycle of violence and trauma is inspirational. Read this book and connect to the need to end the cycle of violence against all women.

Charlene Deuling,
Owner of Expressions Of Time bookstore

Knowing Jenelle and having read this book, I can't think of a more fitting testimonial to her will and endurance. The material is gritty, real, and unflinching in its delivery. Ultimately, it becomes an homage to the inner strength needed to overcome enormous obstacles and the vast capacity of the soul to forgive, heal, and move forward. This is a tale of a true survivor, and it will keep you engaged from the first chapter—an insightful look at the effect of childhood trauma and the ability to rise above.

Colin Hamilton

When I think of a courageous woman, Jenelle is where my mind takes me. I am thankful to have her as a support in my world and am excited to recommend her book as a resource to help you release your power from within. The author is honest with her readers, providing moments of vulnerability balanced with the courage being real regarding traumas that women face in this world. You will cry with her and cheer with her while she reclaims and reconnects with her core self. She shows an internal strength in the way she describes her challenges, resiliencies, and achievements while, at the same time, the gentle empathy of a person who has risen from the ashes. Jenelle shares the importance of courage, dedication, and perseverance in a masterful memoir that can enrich readers' lives in many ways.

Pamela Nevdoff
Pamela Nevdoff Counselling Services

A thought-provoking, emotional roller-coaster that will make you re-evaluate your own life experiences. The book was such a mix of 'I can't put this down' and 'I can't bear to read what's next.' Although my path in life has been different, there were several areas I could relate to. Jenelle's point of view in these relatable situations has made me take a step back to re-evaluate some of my own personal experiences. Sometimes the outcome was a sense of peace, and other times, a rude awakening. Reading even a portion will reinforce your understanding that you truly do not know the shoes someone has walked in and remind you of the resilience one can have when you put your mind to it. Jenelle is an inspiration to everyone who meets her. The story of her past and the path she endured to get here was a painful one. I hope her story travels far and to those who need it.

Sherrilee Franks

When I first met author Jenelle Brewer, she struck me as a strong, independent, beautiful woman who advocates passionately for her community. Little did I know of the journey which led her on this path. In this her first book, Releasing Jezebel: Embracing the Lioness Within, Jenelle shares that journey. Her vulnerability, courage, and pure tenacity to live are moving beyond anything a child should have to endure, yet she took these experiences to guide others around her to have the opportunity for a better life. I am honoured to have been invited into her trusted circle.

Gen Acton

This is the remarkable story of an Indigenous woman who, despite a loving family, had her childhood stolen through abuse, betrayal, and trauma. It is also a story of resilience, strength, and determination as she faces the impacts of her past to rediscover and reclaim the powerful and beautiful person she always knew existed within. The story is both disturbing and inspirational and is a testament to the strength of the human will and the capacity to overcome overwhelming obstacles.

Brian T. Guy, Ph.D.
Retired scientist and business leader
City Councillor, Vernon, B.C.

I first met Jenelle in the course of my work with Okanagan Nation communities. Despite her strong positions and tough stances through many difficult times, her deep commitment to justice and fairness and her compassion always shone through. The intergenerational effects of colonialism, residential schools, addiction, and abuse continue to ravage the communities, and the struggle to overcome them so often seems hopeless. Countless numbers of our youth succumb to addiction, overdose, and suicide each year. At the same time, this is a story of untold tragedy, abuse, injustice, and suffering in the narrative. In its essence, it is a story of resilience and hope, while remaining human, alive, and caring throughout it all. I cannot imagine the pain Jenelle would have endured to relive all these experiences and the courage required to openly share this story. However, I'm firmly convinced that the value of her doing so will be immense.

Allan Price

Author's Note

I spent a lot of time thinking about what I wanted to write in my memoir—what I would include and what my story's message would be. When I started, I questioned what people expected me to write, opposed to focusing on the events of my life that I haven't shared, even with those closest to me.

After some reflection, I chose to include many painful events, each contributing to my trauma and subsequent post-traumatic stress. However, along with this uncomfortable account are messages of hope as I achieved small victories towards self-awareness and healing. As you begin reading, know that a brighter side unfolds; I promise!

My intention is to provide those who are struggling with confirmation that they are not alone. During my writing process and while sharing parts of my story with others, I discovered that it provided them with the confidence to share theirs with me because being openly vulnerable created a powerful emotional exchange—I know that this level of reciprocal trust can inspire the ignition of healing deeply-buried trauma.

This memoir was written as my memory served me, but the nineties is still and will always be a blur! It was difficult to condense my past into eight chapters with more to write about in the future.

Releasing Jezebel

I

Recovery

The cold grey sky rests.
A ray of light in darkness—
the walk to the light.

I woke up shivering, surrounded by grey cement walls. Looking around me as I lay on a brutally hard surface, I realized I was in a cold jail cell. It was late spring in 1999, and as the cobwebs slowly cleared from my brain, I began to get a grip on reality. My memory slowly caught up to me through the fog; I had been arrested and had a vague recollection of being placed in handcuffs and put into a car. I was suddenly worried about what was tucked away in my wallet. I knew it wasn't cocaine, but I also wasn't sure what it was exactly. Yet even though I didn't like it, I still used it. This was around the time crystal meth was introduced, so it could have been that. The quality of street-level drugs had been diminishing for years.

Getting fingerprinted was the last thing I could recall. I wasn't scared but instead experienced a wave of relief wash over my entire body. I thanked God it was over because my addiction was a beast at this time, and I knew it was destroying every core

of my being. In a desperate plea for help at the hospital just days earlier, I begged a nurse to admit me into the psych ward. She repeatedly asked if I was suicidal, but I refused to admit I was. I wanted to die for as long as I could remember, and I spent many years taking risks while pushing myself to the edge of death. Standing in front of this nurse, I remembered the last time I was suicidal. At that time, I decided it made more sense to kill my abusers instead of me. There was no way I would take my life, leaving them to live—I constantly reminded myself of the people who deserved to die instead of me.

Another motivation to live and not share that I was suicidal was that I believed deep in my heart that I would recover from my drug addiction one day. I often spoke about how I wanted to get off the streets. I was so depressed and needed help, but I didn't trust the system and decided that having suicidal tendencies on my medical record would be detrimental to my future. So, I wasn't willing to do whatever it took to get help.

I knew my addiction was slowly killing me, and I tried to convince the nurse that it could be considered a slow suicide attempt. Unwavering, she reiterated I had to declare myself suicidal. However, even though I knew that I would be assigned a bed and get the help I needed if I spoke those words, I just couldn't do it. I believed her goal to help me was heartfelt when I saw the pleading look in her eyes, implying, "I am telling you how to do this." I knew she wasn't turning me away but instead giving me the loophole, begging me to cooperate by saying, "I am suicidal." Maybe the addict in me wanted to keep using, but my experience with the system didn't allow me to trust it at this point.

Still lying on the frigidly cold, hard slab, I looked down and saw a mattress and blanket on the floor. Confused, I stared at them and wondered why they were down there and not

with me on the bed to keep me warm. It occurred to me that I may have had some kind of breakdown, but that seemed out of character for me. There was also a tray of food beside me. I don't recall what it was, but it looked cold and grey like the rest of the room. It was likely my breakfast, and I grimaced at the thought of eating, so I rubbed my eyes and rolled over. I was exhausted, not having slept for at least five days. I thought of my friends back in the hotel room; we were in the next town where we were running some hustle. I tended to disappear, so I knew they probably weren't too worried.

I noticed how strangely quiet it was. It was as if I was the only person in the building—like I was in the twilight zone. I grabbed the crappy wool blanket and lay back down on the hard, steel bed with my hands behind my head, my legs up against the wall, and my feet high in the air. Physically, I was remarkably calm, accepting my fate of incarceration as I stared up at the ceiling.

And yet my mind was racing because I knew I was at the end, and I was scared for the first time in a long time. It wasn't the same kind of trepidation I experienced in the past when my life was threatened or when I feared going to jail. It was more about being terrified that I would continue choosing the life I was living. I had been on the run for so long that I lost myself on the streets. I knew I was knocking on death's door, and my imagination conjured visions of what that looked like—a sole grey door just like in the movies, with no walls surrounding it, just emptiness. That door symbolized death, and I could go through it or turn and walk away. I was a shell of the human being I once was, which didn't seem like much to begin with.

Hitting rock bottom, I didn't drink water for months leading up to my arrest, and I was the skinniest I had ever been because I could barely eat. Everything hurt, especially my

teeth, and it was agonizing to chew food. My dealer watched me eat before selling me drugs to ensure I got something into my stomach. Even though he was trying to help me, I resented him and the power he had over me. Sometimes, I thought he cared for me to resolve his guilt of raping me earlier that year. I hated him but couldn't bring myself to escape because I believed I needed him.

He sat me at a table in the bar and told me to pick something from the menu. Begrudgingly, knowing I could choose whatever I wanted, I ordered deep-fried mushrooms— they became my new diet. They were the easiest on my teeth, so I knew I could eat them quickly without making me sick. He expected me to eat real food and argued that deep-fried mushrooms weren't enough. I retorted, "It's food." Spitefully, I ate to get my drugs. I am not patient at the best of times, and when I was an addict, I don't think I knew what that word meant. Sitting there annoyed and fuming on the inside, I was cooperative on the outside, choking down one mushroom at a time, trying not to vomit with every swallow. The truth is that he wasn't the only one who forced me to eat as a condition to get drugs, and I despised each of them for using this tactic to control me.

Back in the frigid cell, I was lonelier than I had ever been. I needed to make a decision, but in my state of despair and with nothing to my name, I could not come up with any options. I only had two bags of clothes, a trace amount of dignity, and a few principles I had managed to maintain. My boyfriend, Damien, died six months earlier, and I lost everything I had along with my grief. I still had my family but couldn't spend much time at home because I believed I had to protect them from the countless dangerous men who could use them to get to me. I loathed the person I had become, continuously moving

through a five-year cycle of switching back and forth from booze to heroin, then pulling through to rise above, only to sink to the bottom again. So, as I lay shivering in silence, I tried to create a list of what I could do. With my mind still racing, I came up with the obvious—spend time in jail and be honest. Although this was a consoling thought, I knew this scenario would include me having to get bail. Calling my parents for money was not an option. It was the one thing I would not ask them for money for because it would devastate my mother to know I was in jail, so staying there was preferred over having that conversation.

I thought I could run away if I got an OR, meaning they trusted me to show up for court on my "own recognizance" because I didn't do anything too serious. My cousin was always trying to get me to go to Vallejo, California, but I knew I would end up dead somewhere. It isn't easy for a drug addict to reallocate to a city where they don't know anyone. Everyone always recognizes my hair, so whenever I hit bottom, the first thing I told myself was that I needed to shave my head if I decide to run.

I used to believe this was the defining moment when I was ready to give up and be done with my life. However, that had been the case for years, and I envisioned dying alone somewhere, most likely in a gas station or an alley. In the back of my mind, I heard my mother pleading with me to save my life after having lost my sister just four years ago. She told me that she couldn't live through the loss of another child. I remembered her recently telling me that she was afraid I was capable of killing her. So, when I thought about my mother's words ringing in my ears, it bothered me that I frightened her when in reality, I would have killed for her. My heart ached that I scared my mother and made her feel that unsafe.

I didn't want her to be afraid of me or to go through losing

another daughter. I knew how hard that was on her when I reflected on having to catch my mother when she almost fainted at my sister's grave during the funeral. Other than the plane ride home, the only thing I remember about the whole affair was thinking it was weird that the casket was on the plane and none of the other passengers other than my family knew.

Was I ready to live now? My addictions had taken over every core of my being and were not kind to me through the years I spent using. I was so sick and tired of everything: the lies and paranoia, the backstabbing, and the hustle. And, even though I had good people in my corner, they were also addicts and just as messed up as I was—so many people died over the years.

My heart ached for Damien from the moment he died; my life was not the same without him. We used to talk about dying all the time, knowing it was inevitable and that the odds were against us, but I never thought about a life without him. I was in complete denial when his time came. He was one of the few people I trusted, and suddenly, he was dead. Encompassed in loneliness, I wanted to cry but refused to as I lay staring at the ceiling in despair. As a young child under ten, I had trained myself not to cry after I was made fun of by one of my abusers for doing so while watching a Disney cartoon. From then on, I refused to shed a tear unless I needed to manipulate someone for something.

The sound of the cell door opening startled me. I was deep in thought, feeling defeated and beyond desperate. I was tired and didn't know what I wanted other than out. I had tried rehab centers to clean up in the past, but I couldn't make it more than three days each time. Once again, I contemplated whether I would let myself die or not. The guard stood at the door and seemed concerned when she asked if I was okay.

Confused, never having experienced compassion from an officer, I responded, "Yes, I am." I immediately felt that twilight zone creeping up on me again. I needed to know what was next for me, so with great resolve, I inquired, "When is court? What am I charged with?" She looked at me incredulously and said, "We tried to wake you up for over 24 hours; no one could wake you. We were worried and had to bring in medics and eventually take the mattress away and the blanket off of you." Their goal was to make me uncomfortable, so I would wake up.

Looking at the mattress, I thought, "Well that makes more sense." Then returning to the moment, I repeated, "When am I going to court?" She told me that charges weren't being pressed and that I could leave. Then, with a tone of annoyance, she added, "We wanted to release you, but no one could wake you up. We had to keep checking to make sure you were breathing. There are no charges, so you can go." At that moment, I experienced my first "walk of shame" because I was sober enough to be aware of how I was feeling for the first time in a long time. There is no dignity in leaving a jail cell, especially when your stay is unwelcomed and they can't get rid of you.

I was humiliated following her down the corridor as a walking, living, breathing mess. But I'm not going to lie, there was a sense of relief that I wasn't going to jail. I grabbed my few belongings and waited anxiously to see if this was a mind-game trick and if their next move would be searching my wallet where my dope was stashed. I looked curiously at the officers to see if they were interested in going through my things, but they seemed preoccupied with getting rid of me. So, I walked out of the police station squinting in the sunlight, without caring what day or time it was and headed to the nearest bathroom at the mall to get high.

I called the guy I got the drugs from and told him that it

wasn't cocaine, so I wasn't going to pay him. He screamed that he would kill me, and I told him to give it his best shot and to fuck off, and then I hung up the phone. I don't remember how I got back to my home in the Okanagan Valley, but I probably hitchhiked, possibly catching up to my friends and got a ride. Because I was paranoid about being followed, I switched from my usual short skirts or tight jeans to an oversized hoodie and sweats. I had long used recognizing a person by their gait before seeing their face as a survival instinct, and I knew others did the same. So, I ditched the makeup, hid my hair, and wore baggy clothes because I didn't want to be recognized.

Since I was a teenager, I dedicated my life to being drunk or high 24/7 to avoid my trauma and emotions. Getting out of jail didn't change that, and the desire to stay numb was greater than my desire for a better life. I think the addict in me wanted to believe that I couldn't face my trauma or feel my emotions, so I told tell myself I would commit suicide if I became sober.

My childhood was full of traumatic experiences, and the subsequent pain fueled my addictions. The vicious cycle of self-abuse began alongside more trauma and the need to numb more pain. I lived in emotional agony while refusing to express grief or any other emotion except rage—and happiness when I was wasted. I spent every waking moment for years trying to be stronger, only to make myself weaker. I was waging a war with my mind, and I just wanted to forget everything that had happened to me.

The week I came home, I was raped by a bad date. Normally, I didn't bother with medical treatment, but my friends insisted this time because they believed I needed medication. I went to the hospital the next day, and as soon as I got there and disclosed that I had been raped, they called the RCMP. I protested because I was high, had drugs on me, and didn't want

to deal with the cops, but it was standard procedure. The nurse came in and did some tests, but it was too late to do a rape kit. I knew the officer who came in next—I knew most of them, and they knew me. We had a frank discussion about how unlikely my attacker would be prosecuted, let alone convicted since I was a sex worker. This was a conversation led by me when asked about pressing charges. He agreed with me and didn't deter me from pressing charges, but he knew I was right. It wouldn't go anywhere in my favour within the justice system.

He sat with me for a while, and then I disappeared to get high in my hospital room bathroom. I'm sure he knew but didn't say anything. I remember thinking something must be wrong with me that I risked using and getting busted just feet away from this officer. He was sitting on a table of some sort with his feet swinging back and forth when I returned. For a split second, I saw a real person behind that uniform. He took the time to talk with me for maybe half an hour to an hour. We talked about me, and exasperated, he asked me what I was doing. I could tell he saw who I really was through all my bullshit and the masks I displayed to protect myself.

We shared the kind of person I could be and talked about getting off the drugs and the street. This latest sexual assault was a breaking point for me, so our conversation was perfect timing for me to commit to being truly ready. Every time I think about this man, I recall questioning the fact that dispatch sent a man as opposed to a woman to a rape call. However, at the same time, I get overwhelmed with emotion because he ended up being the person I needed—he was one of the few people outside my world who saw someone different when he looked at me. I can't quote his exact words, but I heard and absorbed what he said to me, and I walked away believing I could be someone else and do better.

The conversation I had with this officer was pivotal in motivating me to go to a rehab center. I often wonder if I would have gone to treatment if this man hadn't taken the time to treat me like a human being. How he talked to me may have resembled gentle coaching, or he may have been assertive; I don't remember. However, I do recall that he spoke genuinely, and his message was real. This was the first time I did not perceive the police as the enemy, and this pivotal inspiration came exactly when I needed it and was provided by the helping hand of an angel disguised as an officer. Never in a million years would I have guessed that what I needed to hear would come from a cop because any trust I had in law enforcement was severed when a police officer sexually assaulted me when I was 18 during a raid at a crack house. It greatly added to my skepticism of authority.

After leaving the hospital and the police officer who gained my trust, I went downtown to share my realization with my friend, Destiny. I found her in front of one of the old hotels and told her I wanted out. Unfortunately, she did not, and I knew then and there that I had to continue my journey on my own. So, inspired by my angel cop, I began planning my road to recovery. I had tried to detox not long before and was unsuccessful, but I was ready to try again. Physically, I was in so much pain from being malnourished, dehydrated, and exhausted, and I knew that withdrawals could be dangerous for a drug addict, especially when the user takes high doses of drugs. There are risks involved while managing detox symptoms by taking Ativan and Clonidine. However, Damien taught me how to do it carefully. For added safety, I got a blood pressure monitor to support me through each step.

Before I could start my at-home detox program, I went to a medical walk-in clinic, hoping to get the medication that I

needed. When I disclosed my plan to the doctor, he flat-out refused, being adamant that it was too dangerous because I could kill myself. He was also convinced I was just another drug addict hustling to get the Ativan. I argued that my motive was genuine and that I had done it many times and knew what I was doing. This led to an argument, and he called me a junkie and kicked me out.

When I refused to leave and caused a big commotion by yelling and swearing, another doctor came out to check what was happening. I repeated my situation, and he agreed to help me. However, he didn't give me the prescriptions because he also believed it was too dangerous, but he convinced me to use methadone as my detox support medication. Until then, no one could persuade me to take that stuff, but I was finally willing.

The requirement to start and continue the methadone program is to provide clean urine tests every five days. I avoided doing drugs for as long as I could, and when my test was due on the fifth day, I screwed up every single time and then went and used. Although I didn't want to screw up, I always did by using cocaine, and the couple of times I used morphine, I flopped lifelessly on my side. A few times, I was close to an overdose when I used morphine while on methadone. Then, after a scare when I found myself puking my guts out in the bus depot bathroom and temporarily losing my vision, I stuck to cocaine. After providing my fourth hot piss test, the doctor administrating the methadone program was not gentle with me. He yelled, saying that I was going to die and asked if that was what I wanted. Looking me straight in the eyes, he told me that if the drugs didn't kill me, malnutrition and dehydration would. He cut me from the program.

I panicked and begged him to keep me on it for two more weeks to give me time to find a treatment centre that would

admit me. I didn't know if it was possible, but he agreed after I told him that I didn't want to die. My friend, Ginger, sat with me after that appointment, and I remember telling her I was kicked out of the program, and I was going to have to look for a recovery centre. She stopped what she was doing, looked up at me, laughed, and told me that really sucked. However, she had no intention of quitting, and I cried, realizing that recovery meant giving up everything and everyone I knew. Ironically, her family was simultaneously staging an intervention, and she ended up going to treatment.

The next day I reached out to two different drug and alcohol counsellors and begged for them to help me find a centre. They recommended a local treatment centre, but my aunt worked there, and she was worried I wouldn't be honest, which would affect my ability to participate fully in treatment. I agreed. The protocol to be accepted into a recovery program in British Columbia was to be fully detoxed for a specific number of days before being admitted into a treatment centre. With only two weeks leeway from my doctor, I didn't have that time to detox, and I knew I couldn't do it on my own. However, there was one option in Western Canada that provided detox along with treatment. The caveat was that I had to go to a private centre, and it came with a high cost. I didn't have money, so I asked my parents for financial support, and they agreed to pay for the facility; I got in right away.

My sister drove my parents' Ford Bronco, and my mother sat with her in the front. My dad had lost his sight years before, so he accompanied me in the back. Looking out the window, I contemplated the new life I was about to embark on. And yet, I became disgusted with myself as I shot up one last time. My arms were so sore and scarred that I could barely straighten them, let alone find a vein. I wondered what was wrong with

me—why I couldn't stop using, even while sitting in the car with my family. I immediately moved to self-loathing and then that ever-present shame.

We went for my last meal, and I ordered a beer, unconcerned about showing up sober because detox was part of the deal. When we arrived at the treatment centre, I noted there was nothing impressive about it. I had packed my bathing suit, but there was no pool. Similar to the other residents, I thought I was going to a resort. When I arrived at the door, my bags and other belongings were immediately stripped from me and searched for smuggled substances. I had confidently stashed my Ativan safely in the waistband of my sweatpants.

My excitement for my new journey began to fizzle away when I walked by a group of people playing charades. As soon as I met my new counsellor, I declared that there was no way in hell I was going to play that game. She curtly informed me that I didn't have an option. I did my intake, and they took a polaroid of me, so I would remember where I came from when I left. My counsellor seemed harsh and unhappy. She reminded me of my mean grade-school teacher whom everyone feared. We talked about my drug use, and she asked me why I decided to come to treatment and if it was what I wanted or if it was someone else's idea. She then asked me how I was funding my addiction, and I told her I was an escort. Before I could say another word, she stopped me and said, "No, you're a prostitute." I didn't respond and sarcastically thought, "This is going to be fun; what an asshole."

II

Trauma

The grass grows taller.
Sun burns bright into the night—
darkness falls on all.

Julia's perpetrator was often set off by the most trivial things,
like having missed a crumb while sweeping. Her beating was
once motivated by the dirt not being picked up perfectly. I
developed a neurotic behaviour of sweeping every crumb from
the floor that has lasted a lifetime. I tried helping with her
expected chores, so we would have time to play, but when I
did them incorrectly, she was set off in a panic fearful of the
punishment she would get for my mistake. In my naivety, I tried
to intervene and got spanked. However, it was nothing like the
brutal beatings she was used to, but it scared me, nonetheless.
I screamed on the inside and wondered how I could stop the
callous acts of cruelty continuously inflicted on her. But I could
not because I was a mere child. To this day, I sit with tears
filling my eyes, and my heart aches with guilt and regret unable
to erase her suffering from my mind.

She was my friend, a foster child who was regularly beaten.

I hated going to her house, worrying about the likelihood that her abuser would strike while I was visiting. But she pleaded with me to be there as much as I could. She confided in me that the risk of her being victimized when I was there was much less, so I continued going. When the time came for me to go home for one reason or another, her eyes begged me not to leave, and I waivered because I knew there was no guarantee she would be safe.

So many decades later, I still become triggered by the paralyzing powerlessness that envelops and moves me into an absolute frenzy: clenching teeth, rising blood pressure, and the uncontrollable urge to fight. This state sometimes escalates to the brink of irrational judgment, and I'm convinced I'm losing my mind. Instead, I concentrate on fighting the rage that builds within when thinking about me as a child, being both witness and subject to the injustice of this abuse.

Many times, in my teens and twenties, I sacrificed myself to defend another. More than once, I stepped in between a friend and someone wielding a knife without considering my safety. Even now, when someone cannot defend themself, my instinct kicks in, and I am catapulted into fighting mode. I often wonder when I stopped caring about whether I lived or died. However, years of reflection have allowed me to find clarity about how I managed to desensitize from the violence. I was traumatized by the child abuse I witnessed that required me to set aside my need to escape to help my friend. I didn't know it then, but this patterned act of compartmentalizing supported me as my addictions progressed. Having been exposed to some very dangerous people, I subconsciously knew how much abuse the human body could tolerate. That awareness enabled me to tuck my trauma away to make space to support others with theirs.

At such a young age, I had no idea that my instinctual need

to put my safety aside in hopes that I would somehow protect her from more harm would form a pattern for the future. I automatically assumed the responsibility of protecting my friends when they were threatened. I didn't even know what a personality was back then or that it would develop based on the people I interacted with and the events I experienced—both pleasant and offensive. It never occurred to me to resent my friend for asking me to stay with her amidst her inflicted violations; I just naturally did. It seemed to be the right thing to do, and I have never regretted my decisions. There were times when she snuck out and came to my house, seeking a haven to sleep at night, and I was always relieved when she was tucked in safely in my family's home—I wished she could live with me forever. If I had to relive that part of my life, knowing what I do now, I would still protect her. I know this because I don't think it was unjustified for her to find safety through me but rather an instinctual act of the most primal nature in an attempt to survive.

Along with beating her, she was locked her room like a prisoner. The lock was outside her bedroom door, and I sat right in front of it on the hard cement basement floor while she begged me to let her out. I cried along with her, barely able to stand her constant pleading—the thought of flipping the simple lock to set her free terrified me. I wondered what would happen to her if she managed to escape.

My spankings were minuscular compared to what she endured, so I was never worried about my consequences. However, by not unlocking the door, I avoided any responsibility I might have in future assaults while listening to her scream through them. I believed I was a coward not being able to unlatch that lock and let her go, and I resented myself for choosing to be useless on the other side of the door

that kept her captive. The vision of me sitting there, disgusted with myself for not having the guts to set her free, appears before me quite often. I have wondered if turning that lock would have been the better choice. But what we experienced isn't what happens in the movies—no hero ever appeared at the last minute to save us.

My distrust in authority and systems was influenced by having been exposed to people who constantly abused the child they were authorized to care for. She told me that she once confided in the teachers at school, believing they were there to protect her. But they turned to her foster family behind her back and shared that she accused them of abusing her. She got off the bus to a beating with the cord of a vacuum cleaner. After she told me that, I remember looking at that vacuum one day, thinking, "Who would think of using that to beat someone?" She often had to retrieve the very weapon used to inflict her strapping: a belt or a handful of branches. One time, she grabbed weeping willow branches and smiled sheepishly at her abuser. For a brief moment, I thought it was funny until they yelled at her to get a real beating stick, or they would find one twice the size—the humour quickly dissipated with this reality check.

The actuality of her daily existence extended beyond the beatings and hours of isolation in her room. I didn't know what her heightened screaming represented, but I knew it had to be horrific due to its intensity. During these episodes, she was confined to her room with her abusers, crying out, "No" in blood-curdling repetition; it was a different scream than what I was used to. Years later, she told me about the monstrous acts that were repeatedly inflicted on her while being held prisoner by those who were entrusted to love and protect her.

She wasn't the only one betrayed through the suffering

of sexual abuse in that house—I was too. I don't know when it started, but it was never as violent and brutal as hers. However, even though it was not to the degree she was, I was also psychologically impacted by the physical and emotional violation I experienced. I actually didn't know what was happening to me at the time. The second abuser in the house, Chester, told me we were playing, but I didn't like the game and knew I didn't have a choice not to participate. Allowing others to control me became another developed personality characteristic that this house of horrors sneakily bestowed upon me over time.

I remember starting to read Archie comics there. That is how he got things started, inviting me to lay down with him to read the comics to him. I was uncomfortable being alone with him and eventually refused to read the comics anymore. When the TV series Riverdale came out, I wanted to watch it, but I couldn't bring myself to because I knew it would take me back to that place and time. Still, to this day, when I go into a bigger grocery store and stand in line where the comics are displayed, I get a knot in my stomach, being reminded of the abuse he inflicted on me. I become nauseous and have to look away. So, I choose to go to a smaller grocery store where they don't have them for sale to avoid being triggered. When I saw his pictures posted around the community back then, it reminded me of how much I loathed him. During the time we were abused, I never told my mom what my friend and I experienced, but I told her how much I hated him. She hated the word "hate." Now, whenever I hear a kid say they hate an adult, I wonder if it's because of the same reason I hated him. It's difficult to stay objective because sometimes kids just don't like certain people or things with no harmful reason behind how they feel.

Magazines seemed to be his thing, and, along with the

comics, there were porn mags stashed in different spots throughout the house. They were hidden but also easy to find. And when I found them, like most children who had never seen these kinds of photos before, I was intrigued and decided to look through one. He didn't reprimand me, instead asking me to show him my favourite photo; he took this opportunity to pursue his own pleasure. I picked a guy diving into a pool, but I didn't think anything about the fact that he was nude; I just always wanted a pool, so I was drawn to that particular photo.

One of the issues had exclusively female models covered from head to toe in paint. They were intimately licking each other in various spots, and I knew it wasn't normal, and yet, he didn't dissuade me from looking at them. When he asked which image I liked the most in this photo spread, I chose one, but I don't remember much about it. I'm sure that his warped mind believed I was intrigued by the sexual turn on it provided him. But I was too young to interpret it the way he did and became anxious. In retrospect, I know he expected me to see it differently—the way that he did.

I lived in constant trepidation that people wouldn't believe what was happening to my friend and me especially after the school put her at more risk. To this day, I'm uncomfortable talking about my childhood trauma because I remember moments when I sat frozen in fear behind my friend's couch with tears rolling down my cheeks, believing I had no one to turn to and not knowing what to do next. Listening to the intensity of her screams was unavoidable, so I squeezed my eyes shut as tightly as possible, hoping to block out the sound. My entire face grimaced as I covered my ears, tucked in my elbows, and curled up as small as I could contort my little body. There are pieces I don't remember: the eventual releasing of the

muscles of my face, arms, and shoulders when the screaming stopped and then finding the courage to step out from behind that couch—I don't remember the fine details of those bits. I don't even recall when the screaming stopped, but I will never forget its terrifying vibration running through every inch of my body before it did. I grew up despising myself for being a helpless child, and I never wanted to feel that again. I begged my mother to put me in karate, but my request was refused. I was a big fan of Bruce Lee because he seemed invincible, and I believed that if I could learn karate, I could kick some ass too.

I was about 12 years old when I realized what had happened to me at my friend's house. I found clarity that I was a product of child sexual exploitation, although I wouldn't have described it as such—I just knew it was bad—very bad. I was in my first sex-education class when it hit me that he had taken a special moment from me. I cried and sobbed so hard throughout the night that my eyes throbbed and stung, and my head ached. Every inch of my body was so unbearably weak that I couldn't get out of bed. I didn't want to cry; I just wanted to sleep, yet I couldn't. This pivotal moment set a lifelong pattern in motion of reliving all of my abuse experiences and then crying myself to sleep. My life changed with this revelation, and I dreaded going to school the next day. I was in a state of despair and not sure I would ever experience the sensation of joy again. I believed I was different from everyone else, and although I didn't have a name for who I had become at that time, I intuitively knew I didn't want to be a victim of abuse.

That endless victimization was unavoidable for Julia, and yet I got to go home to my normal house filled with overwhelming guilt for not helping her. I found solace by spending time with my dog, Puppins, telling him all my secrets as I cried. I leaned over and cradled his head while he sat and rested his

chin on my shoulder as if he understood every word I said. We went everywhere together, including hiking up a hill to a nearby creek. We had to pass a dump, and there was usually a bear or two digging through the garbage. I never feared them, although I traversed as quietly as possible. Puppins never barked at them either; we both just quietly slipped by them. My dog and I had an intuitive sense of each other; it was like we had a telepathic connection. I used to imagine we were surrounded by an invisibility shield, stopping the bears from seeing us. I was never so confident in my life. But somewhere along the way, I lost that self-certainty. As a result, although I have a healthy respect for their power, I have watched videos of bears running and climbing, and I won't be caught wandering around with them today.

There was a small dam a short hike up that hill where the bears bathed. I used to revel at the size of the claw marks on the trees and the little stories they told of who had been there—kind of how people carve their initials in trees. I used to like to go to that spot and sit and listen to the water flow. It was peaceful before I spent the rest of the day trekking around. I knew what was safe to eat thanks to our indigenous teachings at summer camp, so I spent my days snacking off the land. The water in the creek looked clean and clear, so I drank from it. Later, I learned that the nearby dump was leeching into the creek; who knows what I was drinking. There were probably all kinds of metals and chemicals in that water, yet I survived. My mom denied that I ever did this, but she was always on the phone and probably thought I hadn't ventured beyond the ranch. No one ever seemed to ask where I was; I became independent early on and grew up fast. I was also a bit sneaky, running off, doing my own thing.

I grew up on the Indian reserve on a ranch with horses and

chickens. I wasn't allowed to name them. Not understanding why, I didn't listen and named one Fluffy. I snuck around with Fluffy and tried not to get caught—not because I thought I would get in trouble, but I felt kind of dumb for making a chicken my pet. Now, I know why; Fluffy disappeared one night, and I didn't realize until decades later that I probably ate him for dinner.

When Puppins came home to live with us, I was allowed to name him. We always had working dogs that belonged to the ranch, but he always felt like my dog. So, I called him Puppins without hesitation. I could tell my brother and dad did not like the name, and they asked how I came up with it. I don't know if I ever told them or anyone else, but Mary Poppins was my favourite movie back then, and he was a pup, so I named him Puppins.

I had a pony for a bit, and I was allowed to ride the horses whenever I wanted. My dad taught me to barrel race, and I loved our time together. When I was a teenager, my dad started going blind, yet he continued to drive. It's an affliction called the "stubborn Brewers." Whenever we left a restaurant, my mom got angry when I fought to go with him in his truck. I never listened to her and went with him as a seeing-eye driver, calmly giving him directions by letting him know when he crossed the lines on the road. Again, the "stubborn Brewer" problem. People always say I have a calm demeanour, and maybe driving with my dad developed that trait. I was only worried about my dad's safety, and I knew how important it was for him to be able to keep driving as long as he could. He used to ride bucking broncs in rodeos, which is still a popular sport on reserves. Branding day was a huge event at the ranch, and the whole family came to help. When my dad lost his sight completely, the cows were sold. I was at a loss because I missed

spending time with my family while they were branding the cows. I was fortunate to be connected to my family, growing up on the reserve. My mom was a care aid for my great aunt, who gave me her Indian name Kalpi. I have no idea what it means. In our family, we have two nations within our ancestry. I don't think the name my aunt gave me came from my Syilx ancestors but from our mutual Secwépemc ancestry. My mom used to operate the elders' program, and when I was small, I remember them drumming our traditional songs on hide drums. They sang their songs, and people did circle dances. My great aunt and cousin spoke our nsyilxcen dialect, and I learned to speak the language at a very young age. When my great aunt had a stroke, she quit speaking our native tongue because she could only remember English. My dad refused to speak our language with our family, and when I went to school, I also lost the language because only English was being used.

My mom was older when she had me, and I believed I was different from other children from as early as I can remember because I was alone a lot. Other than playing with my cousins or their grandkids now and then, I had to entertain myself because my brothers and sisters were older than me. Most of them moved out shortly after I was born, and I remember my one brother living with us and my sister moving back for a bit when she had a baby. So, I was mostly with adults until my nieces and nephews were born. After that, I was with older women who spent a great deal of time together, discussing their lives in the community. Although I grew up being comfortable on my own, it created a perception of being an outsider and added to my low self-worth at that time. I still crave solitude even though I don't necessarily like being alone.

Meanwhile, as I stuffed down my trauma, I figure skated, learned ballet, played baseball and basketball, and took

swimming lessons. I continued switching back and forth from this amazing life to Julia's house of horrors until she ran away. I remember her telling me she was going to leave, and I was so happy that she was finally going to be free. However, I was also terrified of what the future would hold for her. Where would she go? Would I ever see her again? Then, the day came, and she finally ran away; I was overwhelmed with losing her. She was the only one who knew what we had gone through, and just like that, my closest friend was gone. I was grief-stricken. She ended up connecting with some extended family and stayed with them for years. She tried to come back at one point, but I think it was all too much for her. Maybe she thought she would feel differently; I don't know, but she didn't stay long before leaving again. By then, I was used to her being gone and found peace, knowing she was safe.

Around then, my resentment kicked in for the people who hurt her—him and those who knew and didn't say anything or protect her. I had rage fuelling inside me, and I didn't know what to do other than rebel. To further my frustrations, I didn't get to go to the high school my cousins went to. Growing up on the reserve, my friends were my cousins—that's the way it was for everyone, and the people I knew from elementary school didn't talk to me because we didn't get along. In grades one to seven, the natives hung out together, and the non-natives were a separate group. I am half white and half indigenous, so when I wasn't getting along with my friends, I tried to hang out with the white kids. Sometimes they let me play with them, but I was often rejected. When I transitioned into high school, the non-native kids I knew from elementary school continued to ignore me. I decided to spend most of my time in the library and went there every lunch hour to read. I studied all kinds of things and finished whatever homework I had.

The rejection I experienced in high school from the few people I recognized further fuelled my low self-worth, so I wasn't motivated to get up for school. I stayed up late every night watching Cheers and Night Court, using laughter as a distraction to numb the pain. I dreaded going to bed because I couldn't block my earlier memories or avoid subsequent crying bouts. My mom was doing her usual by being on the phone all night, so I could watch TV without interruption. And my dad went to bed and got up early to run the ranch, so no one addressed my pattern of staying up late and dragging myself out of bed late every morning. I dreaded going to school and began intentionally missing the bus, hoping my mom would get sick of driving me from the rez to the other side of town. But she didn't, and we often fought about how my tardiness was reflecting poorly on her. I rebutted that if I went to the school I wanted, this wouldn't be a problem.

Eventually, Layla, one of the girls from a ball team I was on, recognized me when I went to my locker after the library one day. She was genuinely happy to see me, called me over, and introduced me to her friends. Everyone else at the school seemed stuck up to me, but these girls were great and became my friends. I got to experience the town life and went to their houses for lunch; I couldn't believe we were allowed to leave the school grounds. The school was on the furthest side of the downtown area, so we could skip and not get in trouble. If we skipped school, we hid out at someone's house. Suddenly, by spending time with these girls, my life changed as we created memories and long-lasting friendships.

When I was a kid, my mom convinced me I should be a lawyer because I liked to argue so much. It became one of my goals in high school. Before that, I wanted to pursue being an Indy race-car driver, but my dad reminded me that girls

don't do that. Next, I wanted to go into the army, but my mom was convinced I would get pregnant. Then, I thought I could be a backup dancer for music videos, but I was moved out of dance to focus on my figure skating. Finally, I considered being a stuntwoman in movies, but I also quit gymnastics for figure skating. Actually, I didn't view figure skating as the opportunity it was. I didn't enjoy it, and there were times when I bitched about being forced to skate when so many girls would have given their left arm to have the chance. When I think of my career choices as a kid, I realize I have always had a streak that craves adrenally-fueled pursuits.

My parents were amazing, giving me every opportunity, whether I asked for it or not. They weren't perfect, but they did their best, given what they were dealt. When my dad was kid, he went to the Kamloops Indian Residential School, and his abuse had long-lasting effects, but he never talked about it. Because of his experience, he refused to teach us our indigenous language. My mom was raised as a strict Catholic, and I suspect she also endured some abuse in her childhood.

My parents never fought in front of me, but I heard them talking at night once they were in bed. I have no idea what they were discussing, and sometimes, I could hear them arguing about something by the tone of their voices. On the outside, our family looked perfect, and in some respects, it still does. I am very fortunate to have the family I have. We aren't super close, and we don't have regular get togethers, but we can count on anyone if we need help. We just don't always ask for it; I wasn't allowed to ask for things from people other than my parents when I was growing up.

I struggled with the decision to share my story because I feared that people would ostracize me. I doubt anyone will, but I felt judged for as long as I can remember. Perhaps hiding

from my abuse for so long created the shame I believed others placed on me. For years, I used drugs to bury my pain—my coping mechanism included a belief that if I didn't focus on my trauma or the emotional suffering that came along with it, it didn't exist. However, once I recovered from my addiction, I could no longer use it to block my pain. As a result, I began to experience the detrimental consequences of the shame that overtook me and the judgment I thought others placed on me. I desperately wanted to hide many parts of me because I didn't think I would ever be accepted or fit into society's norm as the real Jenelle.

Moving into adulthood, I began talking to other sexual-abuse survivors and saw a commonality—our past abuse had negatively affected our self-worth over time. I became clear about how my values were impacted and that I devalued myself. As time passed, I also recognized that when I was a young woman, I longed for validation from the men I was sexually attracted to. I was desperate for their approval because I placed my self-worth in sex, which was what I believed they thought I was valued for. Unfortunately, I didn't realize this until I began my trauma-healing journey less than a decade ago. It was only then that I was emotionally strong enough to sit back and look at the reality of my past without self-scrutiny or accepting my perception of others' views of me. Whether aware or not, some place shame on others instead of genuinely attempting to understand and support them.

Many victims bravely tell stories of being ostracized by people who don't believe them. Sharing these horrific truths often cause disruptions in the fantastical illusions that people hang onto in order to protect themselves from reality. As a trauma victim, I blocked what happened to me for so long because it was almost unfathomable to admit that someone close

to me was my abuser. It was oppressive that the normalization of abuse prevented me from seeing the behavioural red flags as warning signs that could have saved me so much grief. Suddenly, my ability to be intuitive about others became non-existent. The toll it took was, and sometimes still is, mentally, physically, and spiritually exhausting. It took me a decade to prepare to write this book because of the concern I carried about what people thought about me. However, after a lot of self-discovery and personal evolution, I know I don't own what others believe; I can only believe in myself and trust my story.

Pieces of my story are vague because they are still overshadowed by my thought that my friend's suffering was worse than what I experienced. It became complicated because her trauma—which was her story—intertwined with mine. While working on healing over the last couple of years, I saw how my personality was shaped by the experience we shared in our formative years. For the longest time, I didn't think that what I witnessed added to my trauma, but I did recognize the need for professional help to move forward.

At one point, a girl I knew got into trouble with the law, and she received an order for court-mandated counselling. I remember thinking how lucky she was to have this opportunity. I wasn't sure what it entailed, but I knew I needed it too. My mother disagreed, and I was disappointed but accepted her decision because her "No" was definitive. Counselling was still stigmatized at this time, and my mom was always concerned about public opinion. Her decision was final, and I knew there was nothing I could say to convince her otherwise. So, I did not pursue any kind of therapy until I was in my thirties when I realized that my sobriety depended on it, and I wanted to shift some parenting patterns of my own. My road to recovery was filled with ups and downs as I unpacked the abuse and

its subsequent trauma that I continue to manage through my adulthood. While I was in the midst of addiction, I did not believe my psyche could handle reality because I wasn't confident that I could face my demons and work through them.

III

Chaos

Dew on a petal.
The broken stem overlooked—
withering flowers.

Every day after school, I rode home on the bus that stopped at the high school I wished I could attend. My cousins and friends climbed on and shared their day's antics. In the process, they had fun and forged stronger relationships. I intently listened to their stories while quietly longing to experience this new life with them. It was like being a stranger peering into a living room window, gradually being left out and more and more disconnected. Intuitively, I knew my friends were creating new bonds, and I was heartbroken because I could see that I would eventually lose those friendships on some level. I was so envious because their high school was downtown, and they had the freedom to roam, go to the mall, eat at fast food joints, and get in trouble. My envy stopped me from realizing that I was attending a good high school; I only focused on the fun I was missing with my old friends.

As much as I enjoyed their stories, I watched them growing

up and living all these new experiences; my unhappiness and fear of rejection by new people caused me to isolate in the library. I viewed my high school as a prison set in an area that seemed to be in the middle of nowhere. Resentment fuelled anger as I grieved the loss of these friendships. And as the demands of my extra-curricular activities increased, I travelled less on the bus, which broadened the gap between them and me. My mother picked me up from school, and we often argued about me having to figure skate and how much I hated attending this school.

When I was invited into the new group of girlfriends at my school, it was a welcomed relief from my lonely hours in the library. My insecurity of not being good enough told me I wouldn't connect with other cliques at my school. A couple of headbangers had lockers beside mine, and I really liked them because they seemed fun. However, they were trouble, and my mother was so strict that I knew hanging out with them would not be an option. I often believed two people were inhabiting my mind: an inexperienced over-protected child and a trauma survivor with a dark secret. I still lived on the reserve, which was a 20-minute drive to town, so I couldn't spend time with my new friends after school when I wasn't playing sports. However, we had lunch and breaks together and built closer bonds as time went on. I discovered that they lived close to the school, so we went to their houses during our lunch hour. I hung out with my friends off the school campus—many new experiences opened up for me.

I began to resent my after-school activities, but figure skating seemed to be a prerequisite in our family because my mother loved it so much. She thought figure skating was beautiful and graceful, and she never had the opportunity, so she wanted to give me something she never had. Much

to her dismay, I wasn't drawn to it. I wanted to do so many other things, like basketball, dance, gymnastics, and I longed to fulfill my dream of being a dancer in music videos or be a stuntwoman. I was allowed to join other activities but then had to give them up to achieve my mother's pursuit of having a star figure skater.

These time demands for a sport I did not enjoy further fed my resentment and anger. I continued ballet until the classes conflicted with my figure skating practices. I enjoyed ballet but was not sad to quit because my teacher picked on me. She often pinched the back of my thighs with her long, sharp nails and constantly criticized me. I was unsure of her motivation, but I was also certain she thought I shouldn't be there. Later, my mother told me that the other parents commented on how hard she was on me. I never understood why I was the target of her criticism, but her behaviour affected my self-esteem. I never thought I was good enough when she taught me, so I became dispassionate about ballet and also didn't want to be there anymore.

I talked to a few nice girls in my figure-skating class but isolated myself from most other girls, who seemed mean and stuck up. I had to skate all year round—during the regular season and in spring and summer camps. The higher-level figure skaters had to use the smaller arena because our jumps and spins tore up and dug holes into the junior hockey league's sheet of ice. I chose to sit across from the stands in the penalty box, where my mother couldn't scold me. My mom went to every practice, even though I only went to my lessons. I refused to practice but loved doing figure eights; the focus and precision were challenging, and I worked on tracing my edges as perfectly as possible. It was calming, grounding, and relaxing. I easily escaped my day-to-day challenges during that time on the ice.

It didn't take long for me to figure out that if I competed in figure-skating competitions, I could skip school. I began enjoying my new friends but did not enjoy sitting at a desk all day. Many of the girls had solos, but I wasn't given one because I didn't practice. So, I decided to create one and began practicing, hoping my coach would notice and offer to assist me. She saw I was making an effort and helped me with my solo. For the first time, I looked forward to skating. I envisioned freedom from my perceived prison of home and school on the horizon with road trips.

My first competition was nerve-wracking, partially because I was superstitious, and it was Friday the thirteenth. I was shy and didn't think of myself as a performer, so I also didn't have confidence. I remember putting on my competitive dress, which was different than the sweater and warm tights I wore to practice. The spandex was cold and clung to my skin. My sheer nylons covered my legs, which was like being naked compared to when I wore the thick protection my practice tights provided. Our division was called out for warm-up, and I set my blade on the solid ice; I noticed how much harder it was compared to the ice I was used to. Doubt rose in the form of a knot that travelled from my stomach to my throat. I couldn't breathe, and panic set it as I skated across the ice pad. I practiced a few jumps but couldn't feel my edges on the hard ice. Finally, I decided to focus on getting used to the ice because I knew how much it would hurt to slide across the scratched ice with my practically bare legs.

As my warm-up wrapped up, my coach reassured me that I would be fine. I saw hope in her eyes, and I'm sure she had a bit of doubt as she rubbed my shoulders and gave me some final words of inspiration for my first competition. When it was my turn, I skated to the center and began my routine when

the music started. I was so stiff that I could barely skate, and I couldn't help but wonder what had changed since my warm-up. First, I realized I was experiencing stage fright, believing the audience was quietly judging me. Then, as quickly as the panic hit, I snapped out of it and told myself to relax and just skate like I do every day because I knew my nerves were holding me back. All the tension released from one moment to the next, and I landed all my jumps and nailed my performance. I looked over at my coach when I got off the ice to see her crying with happiness. This was a moment of growth for me, a lesson of letting go at the moment and letting myself just be regardless of my fear of judgment.

We all anxiously waited for the results and crowded around the list of contestants as they were being posted. I hovered at the back, and given it was my first competition, I managed my expectations, convinced I would be second last at best. As I waited my turn to read the board, the girls who checked the results before me turned and congratulated me. Shocked, my coach and I looked at each other and stepped forward; I don't even think I thanked them as they walked by. I was prepared to scan the list from the bottom, but there I was at the top—I came in second! My coach stood beside me, jumping up and down and then hugged me. I smiled with pride, but I was still in disbelief. My heart filled with joy and a burning desire to continue competing and achieve more. Since that day, I always say that Friday the thirteenth is my lucky day!

Besides good grades in school, I had never accomplished anything, but this was different because I worked hard for this achievement. I did not fall in love with figure skating, but I continued to practice and became more involved in the sport. I started coaching the younger kids when I was around 14. About a year later, I fully began to participate in skating and

joined the precision team and dry-land training. My team spent a lot of time together, including travelling in buses to competitions. I French braided the other girls' hair, and we wore makeup for our shows. We had fun together in some amazing year-end performances, with my all-time favourite being The Jungle Story. I got to be an ape, and the smaller girls were monkeys. We learned how to do waist-high lifts, and I realized how strong and powerful I was—another great accomplishment!

However, while revelling in my success, I struggled with a different problem. Throughout my years of skating and ballet, I received the message that it was better to be skinny. It didn't come from anyone in an outright statement, but it seemed clear that the expectation was to maintain a low weight. I was mortified and disgusted with myself because, once I hit puberty and seemingly over night, I couldn't get into my jeans. I went from a size zero to six, and I despised the changes my body went through. I couldn't starve myself because my mother and I ate out so much, so I chose to make myself vomit shortly after eating. I had a male friend at school who attempted to comfort me and explained that the physical changes I was experiencing were normal. His comment annoyed me because I was obsessed with my body image, so I ignored him.

Wherever I was, I hid my eating disorder by waiting strategically for my chance to disappear into the bathroom. Then, one day at skating practice, I left the ice to make myself vomit, and one of the girls caught me. I was suspicious that she followed me to the public bathroom because the changing rooms were closer. She demanded that I tell her what I was doing, and my heart dropped to my stomach. Although I was embarrassed, I was also angry because she knew my secret

and disrupted my pattern, so I couldn't keep up my nasty little habit. I spent the rest of the night fretting over how I would maintain my eating disorder.

I believed my body had betrayed me by growing and that I was fighting for my self-worth. I did not want to be fat, but I wasn't the same person when I looked in the mirror anymore. All this negativity surfaced when I looked at myself. I used to be a bean pole with scrawny arms and legs, but now my thighs were thick, and I was disgusted with myself. I loved chocolate and puked up chocolate bars after devouring them. I ate fries and gravy with a can of coke for lunch and then regurgitated them. I struggled emotionally while losing control of what was happening to my body all over again. My obsession became another secret I needed to hide because I didn't like my body and picked it apart when I looked in the mirror. I made myself vomit while simultaneously believing I was repulsive and unlovable for doing it. I was terrified this girl would tell someone, but she never did. I was grateful because I knew I couldn't endure the agony and shame of explaining myself. The only reason I think that I struggled to control my perfectly natural growth process was because my life seemed so out of control, so I was desperate to hold onto something. My friends complimented me on my figure, telling me it was perfect, but I couldn't see it.

Through my body-image battles, I continued developing friendships with the girls involved in skating. One of them regularly chatted with me, and we became good friends. Myra was a couple of years older than me and had a driver's license. I often helped her and her mother at a local concession stand and spent the night at their house to get up for our early-morning skating practices at six o'clock. Simultaneously, my mom helped my brother get my nieces to their skating lessons, so this

arrangement helped her. As a result, she agreed to let me stay in town, and Myra and I became so close that we called each other's mothers, "Mom." She sometimes got to use her mom's car, so we cruised the main street, otherwise known as "pulling mainers." Eventually, we befriended the downtown crowd and got people to bootleg for us when Myra wasn't successful at getting booze on her own. We drove around downtown on Friday nights and pulled over to meet new people, including boys. They were different from high school students; I was convinced we were hanging out with the cool crowd.

With little time to drink, we each chugged a two-litre bottle of Rockaberry Cooler to get a quick buzz. Our drinking progressed to an every-weekend event, and I got mini bottles of amaretto to bring home and sip throughout the week. My only freedom was on Friday nights because my mother was so strict that I wasn't allowed out on Saturday. Myra's mother closed the concession stand, and we were supposed to be home by ten o'clock to get a good night's sleep for our early-morning skating practice. However, we often stretched that to midnight. On Saturdays, I stayed home and talked to my friends on the phone or made mixed tapes on my ghetto blaster and listened to music. I was accustomed to entertaining myself because my siblings were older and my nieces and nephews weren't always around.

As time passed, my niece began to show promise as a skater, doing exceptionally well, landing jumps at a young age. I was so grateful for her talent and optimistic that my mother would focus her dreams of having a figure skating star on this girl. I encouraged my mother to spend her energy supporting my niece to relieve the pressure on me, but that never happened. My oldest sister, Sage, lived in Ontario and arranged for me to register for a summer skating camp there. We stayed at my

aunt's house, and I skated for six weeks. It was an opportunity for my mother to spend time with her sister and for me to learn to skate from a retired professional skater. However, I was devastated, knowing I was missing out on the fun again! It was like being in grade eight again with my friends having fun without me. I also had to give up drinking for most of the summer but managed to sneak into my uncle's liquor cabinet and pour anything I could find into my pop can. Being stealthy and sneaking booze gave me a rush because my parents never had alcohol in the house. It was my first experience stealing booze, and I thought I was cunning like my friends after hearing tales about them doing the same. I often wondered how they got away with it, never imagining people owning fully stocked bars.

I spent my weekends with Sage in Ontario, and sometimes, we rode the subway to head downtown. I loved the city's core, with the hustle and bustle of all the people, the humidity, and the noise; I was drawn to it, even though it was foreign to me. I also loved going to a larger centre in British Columbia, which I didn't frequent often. While there, I learned a lot, but it did not ignite my passion for figure skating. Instead, being there sparked a desire to return to Ontario.

That summer was like a six-week-long workshop, and once back home, I was happy to be back in time to get some partying in before school started. The most excitement I had was getting into a nightclub one night and dancing with some guy who bought me rounds. I thought I was really mature, having one or two cool stories to tell. I also made a pen pal while skating, but my summer was generally uneventful.

Around this time in my life, I became more and more promiscuous, developing an addiction to male attention and acceptance. I began to wear short skirts bought in secret and

changed into them when I got to school, so my mother never knew. Willow was another friend of mine who dated a guy who was 21 years old. I was shocked, having no idea that an adult would be interested in dating a teenager. However, he seemed nice, and he and his friends sometimes picked us up and crammed us in his small car to go for lunch at Wendy's.

It was a revelation that I could date older men with money and cars—something I had never considered. My challenge was that my mother had goals for me, in particular, figure skating goals. She also wanted me to focus on school, so I wasn't allowed to date. My solution was not to date anyone and to just sleep with them. My promiscuity supported me in avoiding the pain of my childhood trauma, and I didn't care what anyone thought. When I had sex, I forgot everything I was forced to do as a child. I was in control of my body and my entire being. I made my own decisions and became more confident.

The attention from men fed my ego and confirmed that I was attractive and desirable. For as long as I remember, my cousin, Alex, nicknamed me "Ugly." Years later, I realized that it was a term of endearment because I knew he loved me. But it was cruel, and he convinced me I was ugly for most of my childhood. When guys tried to date me, I pushed them away. I was too embarrassed to tell them I wasn't allowed to date and was ashamed I had to follow my mother's rules, which seemed so childish and ridiculously restrictive. Everyone around me seemed to have so much freedom. Even if I could date, I had to rely on my mother to drive me into town, and there was no way I would do that! I was convinced my parents didn't care about my happiness and were trying to ruin my life. To me, their rules made no sense.

Meanwhile, under the veil of their overprotection, I had become an alcoholic and didn't even know it. I wanted to believe

I was mature while running around with older men, yet I was so childish, sneaking behind my parents' backs. I longed for the independence the kids in town had, being free to explore and hang out at each other's houses. My mom got angry because I never invited my friends to our house, but I didn't want to be stuck in a home I believed was a prison. Life was passing me by while my friends were having fun without me.

The following year, Myra went to Saskatchewan for the summer. I had my driver's license by now, and my parents bought me a car, so I could get to figure skating on my own. I spent a lot of time with my friends from high school that summer. We partied at a private bar, and most of us were single, enjoying being young and adventurous. We were often invited to one of our friend's place; his parents went out of town for work now and then, and he had a lot of freedom.

I was anti-drugs back then, and alcohol and cigarettes were the only things I consumed. I was adamant that drugs were harmful and refused to smoke pot. One warm summer night, I was on the docks at the local beach; the sky was clear, and the moon was bright. The same guy whose house we frequented tried to convince me that I should try smoking pot. I did my same old "I don't do drugs speech," but he challenged me, explaining that alcohol is hard on the liver. He also argued that it causes people to be violent, while pot was a safer alternative. He finished by saying that I had no defence because I only drank and hadn't tried pot.

He was right, I couldn't argue, and I never tried it. Sitting on the dock that night, I took the joint and gingerly inhaled some smoke. It wasn't bad, but it made me hack, and I just shrugged because I didn't get high at all. I didn't understand the big deal and decided that I preferred drinking. We left the park and as I drove down the road, a car suddenly approached

on the wrong side. The headlights shone directly into my eyes, and I was confused because the car was coming straight at me. And when I looked to the side of the road, the lines seemed to be on the wrong side as well. I quickly snapped out of my daze and realized that it was me driving on the wrong side of the road! Holy Crap, I was so high, and at that moment, I decided I loved it.

I spent more time with the guys who bootlegged for me since Myra was gone for the summer. They sold pot and introduced me to bush parties, and in turn, I asked my high school friends to join us. We had a great summer, camping without any parents. I thought it was cool that my friend's dad agreed to set up the tent trailer for us anywhere we wanted to camp. All my friends seemed to have the most relaxed parents, giving their kids so much trust and flexibility. I had never been camping before; when I travelled with my mom and her friend, we always went to places with hotels or stayed with family.

The more I drank and smoked weed, the more I craved their ability to block the abyss of a dark and lonely world. I found comfort in not crying myself to sleep at night. And when I drove around with the drug dealers, I deflected my past by listening to their childhood stories—how abusive their parents were, being kicked out of their homes, and resorting to living on the street.

My life didn't seem so bad, and finding other people broken from their childhood trauma meant I wasn't alone. I spent hours with a guy named Jimmy, touring around while he sold weed. Afterwards, we spent the evening driving through the nice neighbourhoods, talking about our future. We hoped our lives would be better one day, like the people living in the mansions we drove by. We thought that maybe we would have big houses and fill them with our families. It was reassuring to

spend time with someone who understood me while dreaming together about each other's future. Our intimate relationship was unlike other friendships I had because we trusted each other and told each other our secrets.

About a decade later, Jimmy died from an overdose—I often reflect on him and our tours around the neighbourhoods. I reminisce about dreams we never fulfilled and think about the futures we lost to addiction. I wonder if our lives would have been different if we hadn't had so much pain to bury. Every time I think of him, my eyes fill with tears and my heart aches for our lost youth and the faded dreams I still long to fulfill. There are times when I wish we could still cruise around and sit and talk about our plans for our children.

It wasn't long before I tried psychedelic mushrooms and acid. This was a whole new experience, and I didn't want to give it up any time soon. Finally, I could release myself into the always-good trips to what seemed like another planet. I have no idea how I managed to do this stuff without my parents finding out. However, I did get in trouble for staying out all night, and my mom grounded me, but then she was never home to enforce it. So, I just left the house to be with my friends again.

I spent more and more time hanging out at my high school friends' houses in the summer, and we found house parties and chilled at the beach. Then, one day on the docks, I saw him—Damien. He pulled himself out of the water, and I remember asking a friend of mine who he was. My friend told me to stay away from him, but it was love at first sight. I could tell he was native. He wasn't tall, but he wasn't short and had black, wavey, shoulder-length hair. He also wasn't athletic, but he was fit and strong. At that moment, he looked like a God to me.

Damien walked with confidence as he made his way through the crowd on the dock with, what I found out, was

his trademark mischievous smile. People giggled and laughed as he walked by, but my eyes locked on him in a trance as he approached me. His arms swayed back and forth with every swaggered step, making my heart race as I looked into his dark eyes that seemed to have a depth like no other man I had met. I had this deep, burning desire inside my chest that I had never had before. I had to have this man. I couldn't take my eyes off him, and I decided then and there that I would hunt him down, and he would be mine.

I snapped out of my trance when I noticed his penis dangling out of his shorts and realized that was why everyone was giggling. I didn't care; I was impressed by his nonchalance and thought he was bold and confident. However, I found out later that he had no choice because back in the 80s, swim trunks were all extremely short, and the mesh in his had ripped. My friend reiterated that I would be better off staying away from him, which made me want him more.

It wasn't long before I saw him again and introduced myself. I went out of my way to get to know him, but he was always on the move. Then, one miraculous night, he was at one of the bush parties, and I practically threw myself at him. I could tell he thought I was sweet but didn't want anything to do with me. I was in disbelief when I discovered it was because I was underage. I was devastated and couldn't wrap my head around why I was too young for him when I had recently dated a 30-year-old. I certainly didn't act like a child but was actually quite mature, or so I thought. I was heartbroken because my first rejection came from the man of my dreams. I didn't take it well and didn't give up, convinced I could sway him. I continued with my life and had a few opportunities to catch up to him. He never set boundaries, which gave me mixed messages, but I eventually accepted that I couldn't change his mind.

It was my last year of high school, and I thought I had a handle on things by now. I was almost leading a double life, having friends at school with whom I shared a ton of good clean fun and then picking up drug dealers and driving them around all night while they conducted their business. I knew many people from each end of this spectrum, and they all took care of me. Both groups were like family, and they accepted me for who I was, even though I showed up as a different person within each side. For most of my life, my mother often reminded me that blood was thicker than water because of how much weight I put on my friendships.

I began going to more parties with the rougher crowd, and one New Year's Eve, I met Manson, who wasn't particularly attractive but was chatting me up. I knew him from my downtown pulling mainers' days. He had a cool Camaro, and I'm pretty sure I was interested in him for that reason. We started dating, and he always acted like a gentleman, and we had fun. He was very generous, ensuring I had an endless supply of weed, and he often took me shopping. The first gift he surprised me with was a beautiful gold chain. I also remember moments when he literally whisked me off my feet and threw me in his truck for a new adventure. He was also kind to my friends, and although I was not particularly attracted to him, he grew on me.

I loved the attention and was enamoured by how much effort he put into spending time with me. He worked at the mill and sold weed, which was different from the downtown guys who didn't have jobs; they were drug dealers, and I couldn't think of anything else they might do. Then, one day at school, a girl approached me to warn me to stay away from him. She was petite and had long blonde wavy hair. Her eyes suggested a prediction of imminent danger as she told me he was psycho

and advised me to stay away from him. I didn't know what to think, so I asked him about her, and he told me she was his ex-girlfriend. He assured me she was just jealous because he had dumped her. I didn't have much experience dating, so I didn't know who to believe. He was incredibly nice, so it was hard to take her seriously. I chose to ignore her misgivings about her, not knowing how much my life was about to change.

IV

Suffering

A haunted child grown.
The forbidden world calls her—
secret walks with death.

Manson overwhelmed me with his grand gestures constantly sweeping me off my feet. He never considered my school or figure skating obligations, and his control was guised as unrelenting love for me. The more I saw him, the more he increased his expectations of me spending time with him, and I began to resent him. However, I pushed my emotions aside for the trade-off of the gifts he showered on me. My attendance to figure skating slowly diminished, and he often followed my car and physically picked me up out of it to carry me off with him. Bit by bit, he became abusive, leaving abrasions after ripping the gold chains that he previously bought me off my neck. He worked at the mill and sold pot as a side hustle, and one day, he and his crew were invited to sell cocaine for someone. I sat with them as they contemplated the risks and benefits, and I remember that moment as if it was yesterday because it was a big decision for them—they eventually decided to proceed with this new venture.

I was 17 when this decision changed the course of my life forever—I began using cocaine and became immediately addicted. Unfortunately, I didn't have a clue how much I was using from our abundant stash of what we called our Coquihalla lines—named after the then recently-opened highway in British Columbia. The beatings became regular not long after the cocaine was introduced. Sometimes I was left in hotel rooms without a phone, clothes, blankets, or towels. I was too ashamed to attempt to escape from the room naked, so I stayed, having developed a pattern of keeping my abuse a secret. His controlling nature forced me to quit figure skating and lost touch with all my friends. Everything seemed out of control as I drowned in my addiction and the abuse.

The beatings escalated, and Manson eventually kidnapped and tied me up in a couple's basement; they happened to be friends of his and newlyweds with a baby. He stripped off my clothes, and I was never untied: not for food, water, or to use the bathroom. He repeatedly raped me, and the husband from upstairs came down from time to time to talk to us and laugh as if everything was normal. As a result, I lost all hope because I knew these people wouldn't help me. I'm not sure how many days I was there, but my friend told me I was missing for at least a week. Lying there, I was humiliated, unable to do anything for myself. My spirit broke, and I wondered if I would get out alive. However, even though I was afraid, I was constantly fed cocaine, so my emotions didn't surface—all I could do was wait to see what might happen next.

I lay there day and night wondering how a mother with a small child could let this happen in her home. Then, my chance to escape came when I suddenly needed medical treatment. Back in the 80s and 90s, most abusers took advantage of being able to stay in the examination room with their victim while

being treated for their inflicted injuries. As a result, they could not disclose their situation to the doctor. Manson took me for treatment, and all I could think about was how I could get away from him. After my appointment, he released me. I was shocked but took the opportunity to get away. At that moment, I chose not to go to the police and went to the local pool hall to find a joint and escape my pain. I never went back to him, and he stalked and tormented me. My other sister encouraged me to get a restraining order, but upon arriving at the police station, I was scared and refused because it seemed that initiating a restraining order was a useless process with the possibility that I would be killed.

Then, Manson threatened to burn my parents' house down while they were sleeping, so I met with him, and he continued to abuse me until he let me go. This event made me realize that I had to do something drastic to protect myself. So, I finally told my drug-dealer friends that he was following and beating me. They formed a watch on me and ensured I was not alone as much as they could, so I wouldn't get kidnapped again. However, he eventually found me at a friend's house and apologized, trying to convince me to meet him as he always did. I refused and told him I was going home. But instead of getting in my car, I stayed behind, and five of my male friends hopped in my car and drove in the direction of my house to see if Manson was waiting for me as I predicted.

Buzz was the driver. He had long curly hair, and he put on my jacket to make it look like it was me. The rest of the guys hid inside the car, and they saw his truck blocking the narrow rural road about one kilometre from my driveway. They told me he stormed towards them in a rage, so they leaped out of my car and chased him. He sped off and got away from them but then, unprecedently, called my mother. He told her that

drug dealers with guns were holding me captive and gave her the address. My friends recounted the tale about how Manson was blocking the road with his car kilometers from my house as I predicted. Later, inside the house, one of them walked up to me and said, "There's an old lady at the door claiming to be your mother."

Well, it definitely was my mother, and she was livid. She didn't call the police but came straight to the house and demanded to see me. I already had so much adrenaline coursing through my body, and then there she was, talking down to me like a child. I was so embarrassed that I decided to leave my friends and go with her. I was high and couldn't drive and my blind father was with her, so I left my car behind because I was afraid to be alone. I went with them, and from the back seat of the car, I shared that evening's story and tried to convince her that I wouldn't be safe at home. However, she wasn't convinced it was a problem that couldn't be dealt with as a family.

My mother had enough, so she devised a plan for me to go live with Sage. It was frightening to think that I was fleeing to save my life, but at the same time, the thought of hitting the big city was much too enticing for me to pass up; I was desperate for change. I wasn't an innocent, wide-eyed small-town girl when I stepped off that plane because I had already experienced the darker side of life. I didn't realize that I wasn't as smart as I thought—although I was excited to be back in the big city, I had no idea what was in store for me. And yet, I thought I was ready for anything!

As soon as I got off that plane, I went downtown and found all kinds of trouble. One of the first men I met was a pimp named Valentino. I immediately adored him, and he took me to cool clubs all over the city. We met up often and had so much fun. He swept me off my feet, and we got top-notch

service wherever we went, whether dancing at the clubs or skipping through security metal detectors. He never tried to pimp me out, and it suddenly ended after a couple of months. Almost a year later, we ran into each other and kept in touch for a year or so after that—I had fond memories of him and still think of him.

I had to do grade 12 all over again, having dropped out months before graduation because of my cocaine addiction. My sister carefully chose a private high school that was recommended to keep me away from high school gang activity. I remember when she dropped me off at this box-like building in the middle of an industrial area on my first day. I saw students wearing Chanel and Hugo Boss step out of their parents' BMWs, Porsches, and Audis. I thought, "Are you kidding me?"

Worthlessness welled up within me because I knew I would never fit into this school. I was a headbanger wearing all black, while everyone around me was dressed in pastel designer clothes and accessories that I could never imagine affording. I thought back to how I used to disappear in the library in grade eight, but my heart quickly sank when I realized there wasn't likely one in a school this size. So, I decided to use my breaks to do my homework, freeing up my time after school and on weekends.

I went downtown during the evenings, and one night, I met Arlo. He was a tall, dark, handsome musician and 23 when I started dating him. His friends treated me like a queen, and I quickly became infatuated with him, falling in love with his sweet, generous, and kind personality. I finished any homework at night on the subway on my way to meet up with him and his friends for drinks. They knew everyone, got me into a lot of clubs, and introduced me to many people.

My social circle in the city expanded, and I discovered

where the after-hour booze cans were. At 17, I was on top of the world, hanging out with club owners, and partying all the time. I suspected Arlo was cheating with his ex-girlfriend, but he denied it, gaslit me, and left nasty messages on my answering machine. Later, I learned it was true, with an important lesson to trust my instincts—I broke up with him immediately.

I met Mercedes at school, and we began to hang out, do homework together, and have fun like normal teenagers do. She was mortified that I had a 23-year-old boyfriend because he seemed too old for me. She invited me to some college parties, and I eventually started inviting her to party downtown. We dated rockers, and we went to the clubs and booze can parties. Although we got into some trouble, it was generally innocent. On the other hand, I just couldn't escape my addiction and need for adrenaline.

I struggled to find a job because I had no work experience— when I was back home, I had to dedicate my time to figure skating and wasn't allowed to work. Now that I was living in the city and no longer figure skating, I had to get a job. After searching for a while, I was finally hired at a clothing store downtown. My boss, Fast-Finger Freddie, hit on me and tried having sex with me, but I refused. He lacked scrupulous business practices and went into a rage when I was honest with customers. As a result, he demoted me to a store window mannequin, making me stand still for hours while people stared at me, wondering if I was real. We were not allowed to engage with anyone at all, but when I changed positions, it made people jump. Tourists took pictures and filmed me; I hated that job. However, one of my colleagues criticized me for not taking it seriously because he fancied himself a model and was thrilled when it was his turn to be a mannequin. I was eventually assigned to just tagging garments in the dingy

basement, and I eventually walked out one day and told everyone to fuck off.

Once again jobless, I partied more, met some new drug dealers, and began selling hash downtown. Then one day, Rader showed up on the scene. I didn't know much about him except that he had a girlfriend, he was violent, and everyone feared him. My friend used to joke about following the blood trail to find him. I ended up hanging out with him one weekend, and he introduced me to crack, which is cooked cocaine. I was in a blacked-out state most of my time with him and only remembered glimpses of the crack houses he took me to; I was unsure if any other memories were real. After three days, I ended up back downtown again.

After a while, he tracked me down and told me to break up with a new boyfriend, who was really sweet and not tell him the real reason why. I didn't want to break up with him, and I especially didn't want to lie to him. However, Rader threatened to break every bone in my boyfriend's body if I didn't. He stood a few feet away as I broke the news that I was moving on. I watched with anguish as his look of confusion turned to heartbreak, and I never saw him again.

Rader was insane and unpredictable, and our time together was full of one violent incident after another. His ex-girlfriend tried to stab me, and I wished she would take him back so I could be free of his control and anger. I was 18 years old at this point, and he was 32—it didn't take long before he forced me into prostitution, putting me on the street every night and making me turn tricks. I was scared and uncomfortable and tried to rob people instead of soliciting them. However, because I was easy to find, the risk that not doing the tricks would catch up to me was too high, so I gave in.

The crack houses Rader and I frequented were dirty and

infested with maggots and cockroaches. I hated seeing all the sad people there who looked like zombies with empty eyes. Yet, as much as I didn't enjoy the effects of using, I couldn't stop either. I was physically and emotionally exhausted, and I hated him and being with him. I didn't seem to care anymore, and one night while walking down the street, we started fighting, and I suddenly called him a fucking goof. It's common knowledge on the street that if you call someone a goof, there is a good chance you will get killed if you say it to the wrong person. The rules are to never rat someone out and never use the word, goof. One of our friends was standing close by and heard what I said. I saw him freeze in disbelief with his jaw hanging open. I knew he couldn't help me, and I didn't expect him to. I just wanted it all to be over.

Rader grabbed me by the neck and lifted me with his 23-inch arms, pinning me up against a nearby bar door. He then dropped me into his fist and crushed my solar plexus. I was a ragdoll as he lifted and dropped me. In an instant, I lay limp on the ground, trying to breathe and simultaneously figure out what he was thinking of doing next while pacing before me. Someone helped me to my feet, and the three of us went into the bar. There was a lot of tension because everyone there had witnessed what happened. A group of guys started mocking and fighting Rader because of what he had done to me. Finally, one of them grabbed him in a headlock, and the waitress took that opportunity to coax me into sneaking out the back door. I looked at her and asked, "To where?" I really didn't know where I could go that he wouldn't find me, so I stayed.

While I could have gotten myself killed, instead, I became a legend for calling him a goof and living to tell the tale. Even though I got a beating that I could not defend myself from and could have killed me, I became more of a legend because I got

back on my feet and went to the bar for a drink. Word spread quickly, and I got a reputation as someone not to mess with.

From there, he and I went to a crack house that was raided while we were there. The city police separated the women from the men, and one of the police officers put a gun to my head and, with his other hand pointed at my vagina, asked, "What have you got up there?" I told him, "Nothing." But that didn't stop him from putting his hand up my skirt while still holding the gun on me and repeatedly penetrated his fingers inside me. I heard the officers laughing around me until he was done. I was numb both physically and emotionally. An hour earlier, I thought I would be beaten to death, and I had been sexually assaulted most of my life—I was used to getting high to block the pain. The other women there were genuinely concerned for me, and I noticed it was the first time I had seen any emotion in their eyes. They hovered around me and tried to console me and check if I was alright. I told them to get away and quit touching me, protesting that I was fine—I just wanted to get high.

Like the gangs on the street, police were just as dangerous, travelling in packs, robbing and beating people. I was relieved to find out that Rader had been arrested. I spent the night passed out in the crack house, and when I woke up, I remembered that I had to get to my exam. I went to the subway and straight to school to write my mid-terms. When I got on the train and sat down, I realized the beating had bruised me right through to my back because I couldn't sit against the seat—for a month afterwards, every time I sat down, the pain triggered the memory of thinking I was going to die. On that day, I couldn't walk straight and was pulled out of the exam because I kept passing out. Sage was called to the school, and all five-foot-four of her grabbed me by my hair and dragged me to her

car—I was surprised she could reach the top of my head. It was the last time I walked through that school's doors as a student until almost a decade later when I was finally clean and sober.

Not long after quitting school, I saw my reflection in a store window one day while walking down the street. I didn't recognize myself, but I looked like crap!! I had the epiphany that I needed to get out of this lifestyle and, although I still used cocaine, I decided to quit smoking crack then and there. However, I kept hanging out downtown and continued to work the streets. At this point, I was confused about my reality and started believing that I chose this lifestyle rather than being forced into prostitution.

Then, one evening, I was on the strip, and a black sedan with tinted windows pulled up beside me. A window rolled down, and I saw four men inside the car; they asked me to join them at a party. It was a rule to decline in this situation, but their charm motivated me to agree. I was instantly at ease, and they intrigued me, so I got in the car. The sensation of a déjà vu came over me—it was like I knew them. We arrived at a condo and partied; I hadn't been given this much cocaine since psycho Manson in high school. They talked about how powerful they were in the crime world, and one bragged about being the boss. From then on, we travelled in limos, ate at restaurants as sole patrons, drank bottles of Dom Perignon, and did tons of cocaine.

There was a flip side because one of them was also a pimp. Goldie sold underage girls to wealthy men, and his entourage worked for him. I became one of those girls and would never fathom leaving where they took me because I was fearful of any possible consequences. He kept all the cash, and I discovered he was getting at least three thousand dollars per call. I was free to come and go but was constantly reminded about how easily

these men would kill me. No matter where I went, I knew they could always find me, so I cooperated and received rock-star treatment with unlimited booze and drugs. They provided me with a bodyguard named Hugo, but I never used him or the limo service attached to him. I was always surrounded by powerful men, including businessmen and hitmen.

When I turned 19, Goldie expected me to get breast implants. Since I refused, I was no longer profitable as a minor. He drew the line about lying about my age, so he decided I would be assigned to money laundering. I wanted out, but it seemed impossible. I was constantly reminded that my life was at stake, accompanied by tales of what they do to girls who don't comply. I was easily swayed because he was so charismatic, and his guys were easy to be with—if I complied.

Then one day, while on my way to the subway station, a strange man pulled up to the sidewalk with his muscle car's T-roof open, providing a full view of him from head to toe. I thought Farid was confident for a guy in his 40s with a belly and who was balding with some visible hair plugs. He wore blue jeans and cowboy boots with metal toes and heel adornments that were popular at the time. He asked me if I wanted a ride, and I agreed because I was curious about who this guy was; he seemed convinced he was so cool but came across as a douchebag to me.

He took me to Mercedes' house across the city and offered me a job. I took it because I hoped it was a way out for me; I also wasn't confident about getting another job on my own. He had a delivery company, and I secretly worked there, hoping I wouldn't get found out. He was a Muslim and had a girlfriend, Kitty, and he wanted me as his second, but she wouldn't have it. We worked side by side, and I talked to her about Goldie as if he was my boyfriend—she immediately knew who I was

talking about because Farid had rescued her from him. Just as he had with Kitty, Farid became my guardian angel—maybe a dark angel but an angel, nonetheless.

Because Goldie was so manipulatively charismatic, Kitty still talked to him and told him she had met me. But unfortunately, he hated Farid because he had taken her away from him, and many conflicts ensued. For example, once, when Farid dropped me off at home, Goldie chased after him waving a gun. I found out later that Farid was a heroin dealer, and Goldie didn't want me hanging out with him. As a result, he once charged into my house, threatening to send me to his rehab. I couldn't stop laughing, which was one of my coping mechanisms in response to fear. He demanded to know if I was trying to get killed while Hugo stood behind him with a pleading look, shaking his head back and forth to motion, "No." Again, I couldn't stop giggling, but my eyes were welling up with tears because I thought I was going to die.

Goldie decided to move me into a condo that I had to share with one of his guys. It was all white with massive windows and an atrium with gym equipment. In the meantime, Farid got me started on heroin, and when Goldie got suspicious, he again threatened me with his version of rehab. Kitty had experienced this, and she told me it involved being in a cabin for an entire week with unlimited booze that she was allowed to drink and piles of drugs she wasn't allowed to touch while being accompanied by a hot guy she wasn't allowed to have sex with. This man spent the entire time getting her drunk and constantly tried to have sex with her and get her high. She failed this rehab, and her beating was so bad that she heard Hugo telling him to stop because they didn't have a shovel.

I thought of the night I first met Goldie when he left me alone with a guy who wasn't allowed to do cocaine but begged

me for some, so I shared. When Goldie returned, he asked if I shared it and assured me it was okay if I did. When I told him I did, the other guys took that man away, and I never saw him again. When I asked, I was reassured he would be fine, but after hearing her story, I wondered what had happened to him.

During this time, I met another bodyguard, Zorin, who worked for Goldie. I often heard stories about what a legend he was. One day, while waiting to catch a cab, he pulled up and offered me a ride. We chatted as he drove me to my destination, and we shared our names; I used my pseudonym at the time, which was distinct enough for him to recognize. We knew who each other was right away, and I was sworn to secrecy, which was easy because I was already terrified of Goldie and so was this six-foot, three-hundred-pound man. We secretly partied when we had the chance to sneak away. Watching this powerful guy be as afraid of Goldie as I was, reaffirmed my reason for being terrified.

My boss asked me to be his second girlfriend again, and he wanted me to move in with him and Kitty. I agreed, but she hated the arrangement and wouldn't let him spend time with me. I was hidden from Goldie in their condo and never went out without someone with me. I was so bored, spending days alone when I wasn't at work and afternoons doing yoga poses that I remembered from when I was young. It wasn't until I returned years later that I realized how big of a heroin dealer Goldie was. For the first time, I understood why he never came for me because he knew the war wasn't worth the consequences.

One day, Zorin called me at work. He told me he overheard a conversation sharing that my pimp decided to put a hit on me. He whispered that I would get a call offering me a lucrative amount of money to deliver a car to Florida. He told me not to take it because I would never make it to my destination and

that I would never hear from him again, and I didn't. However, some time passed, and I heard nothing until I suddenly got a call out of nowhere from a friend in a small local gang. He offered me the opportunity Zorin told me I would get with a fifteen-thousand-dollar payout to drop a car off in Florida. In the early 90s, that was a lot of money, but I declined the offer and said I wasn't interested. The caller was enraged and started insulting me, screaming about how stupid I was. I knew he had only one job to do—to get me to accept this job. I stood my ground, knowing if I did it, I would die. I wondered if I would have been murdered had I not met Zorin and taken the job. However, I knew my time would be up soon and it wouldn't be long before another attempt was made—it was time for me to flee again.

Fear gripped me with Kitty telling me stories, describing the bad beatings she received when she got in trouble. So, I continued to hide out in the condo and spent a lot of time with Farid's lieutenant, Karim. He was younger than his boss, and I was attracted to him. Because I was never allowed near Farid at Kitty's demand, I decided to date Karim and developed a relationship with him; we eventually slept together. After that, I started leaving the house with him more and more and was able to catch up with my friends when we went out.

One day, I had to go to a doctor's appointment. It was a short two-block walk from the subway to the office, so I was confident I would be fine on my own. Walking there, I heard my Goldie's voice call out my name. He pulled up in his new Porsche and asked me to come for a ride. I declined, citing my doctor's appointment, but he offered to wait. To my dismay, I found him waiting for me when I came out, and my heart sank. I had no choice but to get in the car. The months I spent isolating, putting up with Kitty's crap, and dealing with the

conflict I caused with Farid when I dated Karim was all for nothing because I believed I was going to die anyway.

He drove us to the top of a parkade and talked, but I don't remember a thing he said. At that moment, all I could think about was my very Catholic mother. I had heard about people calling for their mothers when facing death, and this became a reality for me. I was convinced I was about to be sent into a headfirst dive off the parkade, and all I could think of was my mother living the rest of her life in torment, believing I was suffering in purgatory after committing suicide.

He pointed out that I seemed nervous, and he was right of course! I was anxious and wanted to run. I wanted out of that car so badly but tried to stay calm, acting innocent and smiling as if I was happy to see him. I explained that my mother was ill and that I had to return to British Columbia right away. He bought into it and gave me five hundred dollars, the only cash I ever received from him. He instructed me to call when I came back and dropped me off at the subway. Watching him drive away, I was confused and unsure of what had just happened. As I held down the vomit that wanted to surface, my stomach was in knots. I fought the tears that welled up in my eyes as I took a deep, shaky breath, and walked onto the subway platform. I finally decided it was time to leave.

Returning to my hometown, I was miraculously unafraid of my psycho ex, Manson, who I had run away from years before. My time away had hardened me due to spending years with my friends fighting on the streets. When we trained, I sparred all day and fought up to three guys at once. I had a choice to fight or be at the mercy of men, providing sex at their demand. I chose to fight. So, when I connected with my friends back home, they saw and sensed the difference in me, but I was still welcomed with open arms. I was relieved to be surrounded by

people I trusted. However, even though I was home, I couldn't return to any normal kind of life because I was always haunted by the fact that my pimp had my social insurance number.

Mercedes fell in love with my hometown during one of our spring-break visits. She moved there, and we got a place together when I came back. I tried to live a life void of drama, but I couldn't work because I knew Goldie could track me down, so I signed up at an escort agency.

Just like before my life got crazy while living with my sister, Mercedes and I partied and hung out together all the time. We did all kinds of fun things, including getting matching tattoos, and for the first time in a long time, I was enjoying my youth again. She had met Goldie, not knowing who or what he was, but she recently told me he was the scariest guy she'd ever met. I never told her anything about what went on because she seemed like such a good girl, and I tried to keep her out of my dark world as much as possible to protect her. I knew that I might put her in danger if she knew too much, and my instinct was to protect her. The fear of her coming into harm's way because of my bad decisions was too great. This coincided with being afraid of returning to being that helpless child, which would reinforce my need to protect her.

Manson started stalking me downtown one day. I was in disbelief because, with everything I had been through, I was back to dealing with him again. I was afraid of being threatened and having to hide for fear of being kidnapped, so I was careful that he didn't follow me when I went home and tried to figure out my next move to protect myself. By now, my friends who had looked after me in the past had jobs, were in jail, or had girlfriends, so I was on my own.

Then it happened. He followed me to the nightclub and walked up to me as if I was going to be happy to see him.

When he approached, my face grimaced as I anchored myself into the ground. My whole body tensed with rage and disbelief about how he dared to act like nothing happened. Memories of the trauma I experienced at his hands washed over me, and all I could think about was that he treated his dog better than me. I was overwhelmed with disgust when I suddenly blurted out, "No." He immediately stopped in confusion with nothing to say. And before he could speak again, my rage motivated me to continue, "No, I am done with you; I am a different person now. I am not the weak kid that you can beat on anymore. I'm not someone to fuck with."

I reiterated that this was a real threat, that I never wanted to see him again and to stay away from my friends and me. I was seething with every word I spewed out at him without breaking my confident gaze with his shocked one. I powerfully shoved him away from me and relished in his response when I told him that if he ever came near me again, I would gut him from his nuts to his neck. Everything I had gone through motivated me to tower over him invincibly, and he turned and walked away. I never saw him again. Finally, I was my carefree self again and as easygoing as I could be, even though in the back of my mind, I knew that Goldie might track me down someday.

Then, Mercedes and I were cruising around one day, and I saw "him" standing outside a corner store—it was Damien. I scared my friend by hammering a quick U-turn, and then, I offered him a ride; it was a pickup trick for boys from when I was a teenager. He got in, and we quickly chatted about not seeing each other for a long time. Although I played it cool, my heart was racing, wanting to blurt out how much I wanted him, but instead, I calmly told him that it was good to see him again. As soon as the door shut when I dropped him off, I looked at

Mercedes in the eyes with conviction and said, "That man is going to be mine." She stared back and said, "I know."

V

Love

Pink petals dancing.
Love meant to last forever—
till death do us part.

I resigned myself to the life I had and owned it. Being back in the Okanagan, my focus was to stay numb and off the radar. I was 19, so I could work at an escort agency and no longer be forced onto the streets. I interviewed at a place called The Studio because I thought it was the safest job, with little risk of legal repercussions. One night after wrapping up a shift, one of the other girls, Bambi, asked me to go out for drinks. I didn't know her well, but I liked her vibe. She used to be a stripper and was very outgoing and fun with a unique sense of humour. Given the cutthroat industry we were in, I was intrigued by the sweet demeanour she managed to exude. When with her, she reminded me of the bubbly personality and energy for life Julia had maintained and others gravitated to. She had the same beautiful, easy-to-style, long-flowing, wavy dark brown hair. And even though people were drawn to her loving personality, full pink lips, and the few freckles that scattered

her cheekbones, her eyes provided glimpses of the hidden pain she carried while sharing light in her dark world.

Since moving home from the big city, I continued trying to find my way. I mostly hung around with guys, and although they were fun, I missed chats and time out on the town with my girlfriends. Most of my high school friends were at college, while others had developed new friendships, so I spent most of my time with Mercedes, but she was often busy with her boyfriend. Being invited out by Bambi was a welcomed change. I was excited to get to know her—we were comfortable together as if we were old friends, sharing a sense of familiarity like kindred spirits.

One night, we headed out to a nightclub that I had enjoyed in the past. We ordered drinks, danced, and laughed. It was great to unwind and have a blast! I welcomed the one-after-the-other triples she fed me. I was used to drinking every day from the minute I woke until I went to bed, and I secretly laced my water with whiskey at The Studio. However, I remember wondering how this woman who was half my size could drink me under the table. I was a few drinks ahead of her, but I trusted her and believed I would be okay. We were surrounded by hot guys and music, and I embraced being weightless and carefree, which was exactly what I needed. I forgot everything weighing on my soul and didn't worry about how I would make the 60-kilometre trip back home at the end of the night. If worse came to worst, I would have slept in my car.

My next and only other memory of the rest of that night was of me sitting in a car while someone was pumping gas. I decided I wanted cigarettes, so I spilled out of the car, not knowing who owned it. While the others tried to help me off the ground, I determined we were on our way to a party. I laughed because my legs didn't work, and my fall seemed

comical. However, I quickly noted how much my hip hurt, even with my intoxication numbing the pain. My attention was drawn to a large scrape, and I knew I would have an inevitable bruise. Amidst assessing my situation, an individual pulled me up to my feet and asked how I was—I could tell I fell hard by the concerned tone in their voice.

In the morning, I woke up hungover and nauseous in a spinning room. It was evident that the party I had no recollection of was over. Lying there with my eyes closed for a while, I didn't want to move to avoid dealing with my hangover. I resisted the urge to vomit, convinced I was living through the equivalent of a slow death. Thirst overcame me because my mouth was so dry that I swore my tongue was sticking to the roof of my mouth. I lay there as if death warmed over, and then the throbbing sensation in my hip hit me—it was simultaneously aching and burning. The image of me falling out of a car came back, and I slowly rolled over, getting ready to inspect the damage. As I began coming back to reality, I rubbed my eyes and slowly opened them to adjust to the light. I thought I would focus on the ceiling first but wait—there wasn't one. What was that? Some sort of canopy; it was pink and plaid with ruffles. With a knot developing in my stomach, I grimaced as I followed the moulded white wood posts and sat up abruptly, "What the fuck? Where the fuck am I?" I rapidly absorbed my foreign surroundings: the girly accents on the walls, the frilly curtains, and the white dresser loaded with stuffed animals, toys, and ornaments. Everything was pink! My eyes were assaulted by this eerie room, and I forgot about my hip as I took a more detailed look around. There was no way a kid was ever in this room because it looked staged, with everything perfectly placed.

I was confused and suspicious as I looked around with fear kicking in. My chest tightened, my breathing became shallow,

and my heart started pounding. My next thought was, "Oh my God, this room is set up for a snuff film." Panicking, I pulled my legs towards my chest to ensure I wasn't restrained. Relieved, I noted I was fully clothed with no shackles—that was a good sign. My hangover brain was reeling with so many thoughts. "What is this? Where the hell am I? Why would anyone have a room like this?" My panic elevated to terror as I froze in the stillness, trying to hear something, anything. But all I heard was my heart beating in the silence. That quiet was not soothing at all but instead triggering with a wave of eerie memories flashing before me. I went back to the silence of a time when I had been forcibly confined, and I knew it wasn't a good thing. To this day, I avoid going into basements unless I can trust those with me one hundred percent.

In this case, I did not know how I ended up in this room, so I convinced myself to stay calm and regulate my breathing. With every tense muscle fighting me, I edged off the bed as carefully as possible and began looking for my stuff. I found my purse—another good sign. As I tip-toed to the door, I thought about my friend, "Where was she? What happened last night?" My head was spinning as I tried to piece the night together to no avail, "I hate myself right now." Getting to the door, I listened for voices while holding my breath, but it was dead quiet. Carefully placing my hand on the doorknob, I slowly turned the handle to check if it was locked. Another wave of relief washed over me as it easily turned. So, I took another deep breath as I inched the door open to a hallway, a beige carpet, and white walls.

I remember thinking the rest of the house looked normal, almost like a show home. It was weird because I expected some seedy dump. I needed to stay focused, so I stopped to listen again, but still nothing. Placing one foot out into the hallway, I

was confident I was safe, believing I must be either at Bambi's house or at one of her friend's places. But at this point, I wasn't sure and just wanted to get out of there. My PTSD triggered all my instincts to run, so I made my way to the kitchen to find a phone to call a taxi. The phone worked, and I dialed the number. The dispatcher asked, "Where should I send the car?" Dammit! I didn't know where I was! I told him I would call back and began quietly snooping through the kitchen, searching for a letter or anything with an address. There was nothing, not even a pen in the perfectly organized drawers with each utensil carefully stacked on top of each other.

Suddenly, I decided I was overreacting and calmed myself down, believing Bambi had to be in the house somewhere. I needed to find her and wake her up to get us home. Walking back down the hallway of white doors, I shuddered as I walked by the creepy pink room. Convinced my friend was in one of the rooms, I went to the end of the hall and carefully opened the first door a crack. A wave of heat washed over me, along with a beautiful orange glow. Opening the door completely, I stopped short when my eyes rested on shelves of snakes and lizards. The hairs on my neck stood straight up, and I quickly shut the door. My search ended because, between the freaky pink room and the reptile room, I didn't want to see anymore.

I decided to get out of that house and go to the nearest intersection to meet the taxi there. I went to the front door and discovered it had an automatic lock, so if I left, I wouldn't be able to get back in. Cell phones weren't invented yet, and I was not about to knock on people's doors because I did not want to interact with housewives and children. At this point in my life, I didn't engage with the families in suburbia because I was up until six in the morning in the bars and at parties with dealers, doing calls all night, and sleeping the day away. The people I

hung around with called "normal people" stiffs, and I would have rather died than interact with them or be one. Ironically, I eventually became one.

I don't know why, but my next thought was to go back to the kitchen to call the office where I worked. One of the girls picked up, "Good morning." I whispered, "Hey." I identified myself to Cherry, and the conversation went quiet for a moment. Having noted the call display, she knew exactly where I was—it was Bambi's place, "What are you doing there?" Again, I was relieved, thinking, "Thank God, someone knows where I am!" I briefly explained my experience and asked if she knew the address. I told her I had to get out of there, and she laughed and told me she would send a taxi right away.

I kind of chuckled to myself, feeling safe for the first time since I opened my eyes, so I drank a glass of water and began searching for my shoes. Standing outside the door of the pink room, I instantly froze, having to force myself to take a step forward. All my instincts told me not to go back into that room, and yet, I anxiously walked through the door and quickly checked for my shoes. Nothing. My next-morning-alcoholic brain kicked in, and I realized I didn't have a clue about what happened, "Where did I leave my shoes?" I wondered if I did something stupid to embarrass myself or, even worse, my friend. Shifting back to my mission to find my shoes, I decided that she must have them—I would get them later.

I refilled my glass with water and sat down on a white armchair by a window. I was impressed by how clean and untouched it looked. Guilt bubbled up, being unsure if I was allowed to be sitting on it, so I rested my butt on the very edge. It didn't take long for the taxi to arrive, and I told the driver, "Just get me out of here!" I zealously recapped my night to the driver with animation and hands waving, ending my story

with, "And I have no shoes." He laughed and told me, "I have your shoes!" When he heard the address that morning, he took my call because I had left my shoes in his cab the night before. He handed them to me, and we had a good laugh. I didn't ask if I made a fool of myself because I really didn't want to know. He dropped me off at The Studio, and I went inside and told the story all over again.

The next time I saw Bambi, I told her my harrowing ordeal of waking up in that pink room and how terrified I was that I would die. I asked her what was up with the lizards and that room. She shared that owning reptiles started when she was a stripper and used snakes; her hobby eventually grew to other reptiles. She told me that the pink room was a replica of her childhood room that she sets up in every house she lives in. I tried not to judge, but I did; it just didn't make sense to me, but I didn't ask any more questions.

It is often said that an alcoholic or addict will hit bottom at some point. I never heard of this term until I was in treatment. Currently, I can't help but wonder why I didn't realize I had a problem given my reaction when waking up in a pink room after blacking out and being certain I would die a horrible, tortured death. I think the possibility of dying or being murdered was something I was coping with because of what I experienced to this point.

Amazingly, it didn't cross my mind that it might be time to stop the mad cycle of addiction. Still, it was more of a priority to numb the pain rather than take a look at myself. I thought it was a hilarious story, but not everyone thought it was funny. I still tell it today and receive conflicting responses. In reality, that experience still triggers fear when submersed in different situations. I don't like being in rooms with doors that can be locked because memories surface of the various times in my

life when several men held me captive in basements. Many women on the street normalize abuse because, even though it is lonely and they live in fear, no one seems to want to help. When I lived among them, it was because I believed I made choices that brought me there, thinking that I didn't deserve to be helped. Sharing my secrets would have been riskier than taking the chances I did.

I was 20 years old when I found Damien again, and we started dating on and off for seven years. Many referred to him as scary. None of my girlfriends and even a lot of the guys I knew didn't like him; they were definitely afraid of him. He had a bad habit of robbing people, and I was kicked out by my roommates when he stole from them and others at the house. I was accustomed to being with terrifying men, yet I saw him in a different light. I tried dating more socially accepted men, but they didn't like that I was an escort, and I couldn't tell them why I chose this line of work. Damien didn't love it, but he also didn't ask me to leave it.

I thought of him as my soulmate, and I couldn't fathom living without him. He hated drinking with me because I often became abusive and got into fights. I was an uncontrollable drunk, constantly getting into trouble after starting my day with a 26-ounce bottle of Jack Daniels. I poured a glass before I went to bed every night, so I could roll over and have my first drink before I was on my feet. When I first watched the TV series, Trailer Park Boys, the main character, Julian, reminded me of myself during my drinking days, always with a drink in my hand.

I went to Damien when I was kicked out of my place and started crashing wherever he slept. He stayed with his friends because he didn't have a permanent residence, and I was simply happy to be with him. I hadn't been exposed to the world of

heroin junkies yet where every minute was a hustle and using needles and scamming was the norm. Not many liked having me around because I was too square and didn't do heroin. But they accepted me over time because I kept my mouth shut, which was the only prerequisite if I wanted to stick around.

Finally, Damien had enough of my drinking and insisted I quit—it was a dealbreaker, or he would dump me. I agreed to stop, and within 24 hours of my first sober day, I suddenly broke into a sweat and began shaking while driving home from The Studio. I couldn't breathe, and my vision was blurry, so I pulled my car to the side of the road and hung out of the door to puke. Confused, I picked up my 90s brick-sized cell phone and called Damien in a panic, telling him something was wrong with me. He reassured me I was going to be fine and told me to come to him for some valium. At the age of 21, I had been drinking for so long that I was experiencing delirium tremens, which is a rapid onset of confusion with severe alcohol withdrawal—I had never heard of such a thing.

Not being able to drink, I tried using weed to dull my emotional pain, but it wasn't enough, so I started using heroin again. I tried stopping after a few days and was reminded of the same withdrawal pain I experienced back in Ontario. Back then, I didn't associate it with the effects of quitting because I did not know there was such a thing as a withdrawal, but going through it again, I recognized the suffering—it resembled what I endured for days to avoid being sent to Goldie's rehab: muscle tension, physical pain, and inability to get comfortable. It was awful, with every cell in my body screaming for more dope. At the time, I didn't associate quitting heroin with the pain I was experiencing.

Damien and I took my savings and invested in some heroin to sell. We did very well. I packed large amounts of it wrapped

in condoms in my vagina to avoid getting caught. Because the police knew us, we got pulled over and searched multiple times a day. Despite being under the watchful eye of the RCMP, we didn't have to couch surf as much but instead moved from hotel to hotel or slept in my car. We had to stay on the move to avoid getting busted. It also seemed like a great solution because I was still afraid that Goldie might catch up to me. Damien was crazy, and I believed if anyone could protect me, it was him. Our relationship was a dysfunctional one full of ups and downs, but it seemed to serve us both at that time. We spent every waking moment together when things were going well between us.

It was after he got out of jail when things weren't going well because I always went back to the escort agency to hang out with Cherry and the girls and started drinking again. We had so much fun, going out and renting boats for the day or taking little trips to other cities. However, when separated from Damien, I sometimes ended up dating other men and eventually stopped visiting him. Our deal was that he took all my criminal charges for me, and in exchange, I brought dope to him in jail. But I couldn't manage my drinking, not even for him, and I usually just disappeared on a binge—that pissed him off.

Each time he got out of jail, we eventually made up. None of my friends or my parents thought he was good enough for me. There weren't many people I trusted with my life, but he looked after me in his way. Every time I returned to him, I quit drinking and restarted my heroin addiction. One night, he and his sidekick came back to our hotel room after hitting a drug store. His friend shot up some pills and started twitching like a chicken with its head cut off. I panicked and ran around in circles in our tiny hotel room as I watched him violently

convulse with his eyes rolling up into his head and his back arching while making gurgling sounds. Initially, I didn't know what to do because I had never been this close to someone having an overdose. I wanted to call 911, but Damien calmed me down, and we dragged his friend into the shower to soak him down until he began to regain consciousness. This was my first lesson on how to manage an overdose, something that was handy in the future. He was grateful to us for bringing him back, but then he and Damien made fun of me for panicking. Being confined to one room with them and my adrenaline still coursing through my blood, I was like a trapped animal with nowhere to go. So, I headed to the bathroom and punched the fridge so hard that it started rocking back and forth. When they made more jokes about how mad I was, I wondered how they could be laughing at a time like this. I was still processing the shock of what had happened, and they treated me like an idiot. They were right; I was angry.

I couldn't snort heroin anymore because my nose became too congested during my withdrawals. I couldn't smoke it because my teeth were already damaged from drinking and vomiting, so I decided to use a needle for the first time. I was 22 years old, yet I felt so old. I remember running into a girl I used to play softball with, and I couldn't believe she was living this life too. I was so afraid of needles, but she was experienced, so I asked her how she did it. "I don't know; I just do," she said. When I was ready to get my first injection, I remembered what she said, and I understood. I had no choice and just had to do it; desperation was my motivation.

Damien didn't give me my first needle. We weren't together then, and he would have refused anyway. When he found out I was using needles, he was not happy. Seeing people overdose became something I experienced more and more,

and he taught me how to make a salt and water mixture to bring people back from heroin overdoses. I saved a few people using that technique. I also learned about cotton fever when someone gets sick when bacteria from reused cotton or needles is injected into the body. It is a terribly painful experience, and the only cure is another injection with sterilized tools. If you don't have more dope, you're screwed and will suffer.

My alcohol and heroin addiction cycle continued, with me hitting one bottom after the other. With Damien doing one of his stints in jail, I began partying hard with Cherry and the girls again. They had left the Studio because the owner kicked his wife out, and he started abusing his power by manipulating the girls. Cherry had enough and asked her mom to open an agency, so when I returned, they were working at a new shop called The Red Affair. While my mother would never start an escort agency, I understood why Cherry's mom did. We needed a trustworthy woman in charge, someone who chose to meet us where we were at; nothing was going to change that.

After one of our nightly escapades while coming back to consciousness, I found myself running through a park with my shoes in one hand and my wallet in another. It was dawn, and I left the park. As I continued running, I crossed the highway, jumped over fences, and took shortcuts through backyards until I made my way home. I knew I had started partying with a big gang and guessed I had been drugged at some point. I never did find out exactly what happened, but others shared stories of the mischief I got into throughout the night.

At some point, I met Destiny through Damien; she was a girl who sold drugs for us. We often stayed with her, and when Damien returned to jail one summer, the two of us partied. He was in a minimum-security prison, and I decided to help him break out. We got into a fight because I showed up at

the jail smelling so strongly like beer that the guards searched my car for alcohol. I went home, and Destiny and I went to a club where the band, Ecstasy was playing. I met one of the roadies earlier that day and scored him some weed, so he put me on the guest list. Spontaneously, we followed the band across Canada and ended up back in the city again, where the tour ended. I knew Damien would be livid, but we didn't think twice about leaving British Columbia with a couple of dollars and a full tank of gas. Our days consisted of eating McDonalds' hamburgers and partying with the band. I had to pawn my gold halfway there to get to our destination.

Once there, we stayed with my sister and continued partying for a while, but my friend had a family issue to manage and had to go home. I stayed back and looked up Farid from the delivery company. I discovered that Kitty fell off a balcony, and the incident was deemed a suicide. He wasn't convinced that was the cause of her death and blamed Goldie because she couldn't stay away from him. This was another affirmation that my life was in danger because I believed our pimp was just as volatile as ever. I also found out that Karim was busted in Thailand, and Farid left him there to rot because he was so angry that he dated me. My heart sank to my guts when I heard this because I knew he likely died there. This was the first I realized they were involved in selling drugs internationally. Regardless, I moved into Farid's place, became his girlfriend again, and I went back to work at the delivery company.

My sister passed away while I was still there, and I didn't handle it well. She was in the hospital and told me she was dying; she swore me to secrecy. However, my mother somehow found out and made it back to be with her daughter when she died. I was simultaneously being pressured to marry Farid. But I couldn't do it because we weren't getting along, and I wasn't

in love with this guy, even with the promise of a million-dollar dowry of jewels and a mansion full of servants in Turkey—if that was indeed true. I also didn't want to stay, even though it had all the heroin I needed. I wasn't happy and knew I had to leave, so I disappeared one day, leaving him my key and a Dear John letter. He had told me that if I didn't marry him, I would never hear from him again, and I didn't.

I returned to the Okanagan and went back to work at The Red Affair. Then, at the end of a night partying with Cherry and Destiny, we stopped at a house to get some cocaine. When we arrived, there was a pimp beating up a young girl while simultaneously saying he loved her. I got up on the couch above this guy and glanced over at Destiny. She nodded that she was ready when I looked over her. This was a signal telling me that she was prepared to back me up in the fight. She was the smallest person I knew but also one of the toughest. I kicked him so hard in the gut that he was lifted back up onto his feet. He immediately directed his attention on me, and a fight ensued, with another guy at the house pinning my arms behind my back. I was eventually freed from him after taking multiple blows to my head. We continued to fight, moving to the next room, and he finally got the best of me, holding me down on the ground. Suddenly, Destiny came around the corner with a cast iron frying pan and whacked him square on the head with it—nothing. She then hit him repeatedly with a chair and all kinds of other things, but he didn't flinch. Meanwhile, Cherry encouraged the girl to run, but she didn't. I understood—she had nowhere to go.

Eventually, the girls got that guy off me, and we escaped to the car, where the other guy pulled a gun on us. I was ready to fight again, but Destiny kicked me in the stomach and forced me into the car. We surrendered and left, assuming he was on

meth or some other crazy drug because his adrenaline was so high; there was no way he should have been able to keep fighting after being hit with that cast iron frying pan. When I was drinking, I was a fighter who liked to see a fight to the end. However, for the sake of our safety, this was one of the few fights I agreed to walk away from for the time being. Damien and I always said, "Better to walk away and live to fight another day."

Another time, Destiny and I decided to sneak some heroin into work. We picked up some dope and needles and returned to The Red Affair. I shot up first but was so drunk that I forgot to split it and did the whole hit. I didn't do it on purpose because I knew I couldn't handle that much, having not used heroin in a while—many fatal overdoses occur when someone goes back to their last dose amount after having not used for a while. The next thing I knew, I was hanging over the toilet vomiting up a thick, black, burning, sticky substance, and Destiny was over me yelling, "You did all of it, and you fucking died." She had to break into the bathroom and revive me, so we didn't get caught.

When I woke up the next morning in one of the bedrooms of the makeshift studio established in a duplex rental at The Red Affair, my body ached as if I had been run over by a dump truck, almost like a hangover but much more intense. The memory of the black tarry vomit and the screams that I had died came back to me, and it all seemed like a nightmare more than reality; the evidence of pain was too much to ignore. There was no heroin and definitely no needles allowed in The Red Affair, and I did not know what I was waking up to. This wasn't just where I worked; it was a landing place for me when Damien was in jail, and I was afraid of losing it. I gingerly got out of bed and went to the living room, where I was handed a joint and everyone seemed to be acting normal, except Destiny who saved

my life. She sat there glaring at me like she wanted to kill me. Although, I had no recollection of what had happened, I knew right then that I had overdosed and had some explaining to do.

It wasn't long before I was in another violent relationship, needing to escape. I fled to Vancouver. I was 25 years old by now and still running for my life and now hiding from Damien since the cross-country trip fiasco. This new boyfriend was particularly dangerous, but I had a good friend, Wolf, who helped me detox in the past at his uncle's by leaving me there without a car and no way to get drugs. We met years before and tried to have an intimate relationship, but we couldn't have sex because we were too much like family; it was like I knew him from another life. I ran into him at the courthouse, and he saw my face all busted up and offered to get me a place to stay. I memorized his number, and in an attempt to escape from my violent boyfriend, I took him up on his offer.

Wolf moved me into his cousin's house. Then, one night, a group of us were sitting around playing cards one night, and I had this overwhelming feeling that Damien had HIV. Out of nowhere, I blurted out that he did and I had to find him. Everyone discouraged me from hunting him down, but I had a strong urge to connect with him. It took a while, but I finally found him. He told me exactly what I suspected—that our relationship would never be the same because he had HIV. He ended up moving in with me, but when he found out that Wolf's cousin had raped me one night when I was passed out, he beat him up. We immediately moved out and found a place in downtown Vancouver off East Hastings Street. The area wasn't as bad as it is today, but it wasn't great. I didn't like doing crack, but we were both smoking it again. When I was high, I listened to the seagulls from the ocean nearby. They sounded like my childhood friend screaming when she was being beaten.

When I heard the seagulls cry, I was convinced there was a girl being tortured somewhere. Just as I did behind her sofa years ago, I curled up and held my ears to console myself. But I was unsuccessful.

We returned to my hometown and did anything Damien wanted; it was part of our HIV death pact made during our earlier years together. Unfortunately, that included being involved in a gang war. So, we got high and ran around with guns when he wasn't at the doctor's or at home. After each appointment we returned to the car, and he shared blood cell number counts that I didn't understand. I was completely delusional and in denial as we talked about a future that could never exist. And when we weren't in denial, I reassured him that he wasn't going to hell for all the things he had done. Then one day, he woke up different. We were in a hotel room, and he was freaking me out because he didn't make sense. I insisted that he go to the hospital, and I'm not sure how I got him to agree. The doctor confirmed that he was dying and blamed me for his decline and death a few days later. I never really understood what was happening; all I worried about was him being in pain and needing more dope.

After he died, I experienced anxiety to a degree that I never had before, being afraid I would die and refusing to drive during the days leading up to his funeral for fear I would get in an accident. My nephew drove to decrease my anxiety; nothing was real to me. After the funeral, I plummeted, doing cocaine for weeks. My memory around this time is minimal, but I know I couldn't deal with my grief. I began hanging out with one of Damien's old friends until he started getting paranoid. Then, Ginger invited me to stay with her and her boyfriend.

As I continued to avoid the pain of grieving my boyfriend and my sister, I descended to a new low. I couldn't keep it together to sell dope or even remember my dealer's number in

Vancouver. I was also afraid because I owed him an accumulated debt as a result of Damien doing all of our dope before he died. It was so strange to suddenly experience this degree of memory loss.

There were moments when I forgot he was dead and talked to him as if he was with me, only to suddenly realize he wasn't there. My life seemed completely empty without him in it, and most of the drug addicts I was surrounded by were clearly out for themselves—I was at the mercy of the few willing to look after me. Ginger was my biggest support during this difficult time. I'm not sure I would have survived without her, who knows what might have happened if she didn't take me in. I searched for a way to continue dulling the pain by maintaining my addictions, but I couldn't pick myself up. It seemed impossible to get the help I needed, and I was too far gone to go back to The Red Affair where I could usually get on my feet again. I lived with constant desperation, experiencing depression through dysfunctional loss and suffering; I was so emotionally paralyzed I didn't even know it.

Ending up in the city cells was the wakeup call I needed. I was choosing to live while simultaneously wanting to run for my life. I desired committing to who I truly was, the person I had lost along the way and that was most likely the little girl curled up behind that couch so long ago. I was about to learn about the masks I created to manage my pain and hide my weakness and fear from the world. For the first time, I was willing to seek help. I was full of hope and ready to leave it all behind…except for my last few pills that were tucked away along the string of my sweatpants. I knew that this was something only I could do—it was just me now, sitting across from some asshole, calling me a prostitute.

VI

Transition

Walking the dirt road.
The lioness and her cubs—
embracing their strength.

I learned a new term in the treatment centre—sugar coating
is when people hide the ugly truth with pretty words to make
it sound better. I didn't hate the place, but I would have liked
it better if it had a pool. I spent the first month detoxing from
methadone, which was more difficult than anything else I had
quit. It took the entire month to gain the strength to go out
for the forced, scheduled walks, and I didn't get much sleep,
often staying up all night playing crib with the night attendant.
We upped the ante to speed crib at one point to make it more
interesting. Being awake within the silence of the building
while everyone else was asleep disturbed me and made me
anxious. However, this became a contrast to years later when I
could only sleep in total silence.

After receiving medical care for three weeks, the doctor
decided to cut me off my medications. However, I was very
aware of my detox process and how my system responds to

it from past experience. As a result, I knew I was in trouble without the support of any medication, and I had run out of Ativan. I tried to convince the doctor he was making a mistake, but he dismissed my concerns. So, the next day during a support group session, I experienced a crisis, breaking out into a sweat and being totally drenched as if I had just stepped out of the shower. Shaking, I could barely see clearly as I inched my way down the hall, leaning against the wall for support. Fortunately, it happened when a doctor was on duty, and my medications were extended. Unfortunately, the withdrawal symptoms continued for another two weeks, and my constant visible shivering and intermittent shudders down my spine often scared the people I sat with and talked to.

Coming through detox, my vision cleared enough to read again, so I could begin the required workbook for the program I was two weeks behind starting. It didn't take me long to realize that I was in a significantly different state of needing repair than my peers. Most of them were businesspeople, stockbrokers, or housewives with drinking problems, and a few had cocaine addictions. Some unions sent their employees for support, and it seemed that most were drug addicts, but from what I could tell, not many had lived the kind of life I had. Unworthiness did not kick in for once because, even though I was much worse off, we were all there for the same reason—addiction rehabilitation.

My counsellor earned my respect because she was a no-nonsense woman and a straight shooter. I went to my group sessions and revelled in the joy of being able to share my opinions straight out. As a fellow addict, I was interested and annoyed, seeing through the games the others played. Some were wealthy and believed they didn't belong there, even though they clearly were, having been forced through intervention.

There was one woman in her 80s with short, white hair and was frail and hunched over. She cried when it was her turn to share in an attempt to get out of speaking her truth. I saw right through her little scam, yet I liked her because she reminded me of my mother if she were an elderly woman who drank and smoked.

One day, I told her I could see through her bullshit and fake tears and it was time for her to own up to her crap like the rest of us. I got dirty looks, and everyone gasped, with some immediately scolding me. The facilitator put his hand out, thinking that would shut me up. I became defensive for being criticized, but she looked up and agreed it was an act. She told me no one had ever spoken to her like that and thanked me for treating her like a strong woman instead of a feeble old lady who couldn't handle the truth. We became good buddies after that, hanging out in the smoke pit. We kept in touch until I was on my own and didn't have a phone anymore. She was in treatment because she was ill, and her family didn't want her to die as a drunk. I hoped she was with them during her last days, not alone and enjoying their company.

I still managed to get into trouble with the assigned tattle tales. We each took turns as a monitor, with our shift including room checks and a public report listing all the messy resident rooms. I remember scrambling to get things put away during room checks to avoid getting called out during what I referred to as the "shame circle," where the monitor read out the specific disarray in each guilty person's bunk. One time, I left a banana on the bed, and the jokes started to fly. For weeks, I couldn't eat a banana without being harassed. I wondered why they couldn't let that one slide, but I wasn't really offended, knowing there was little opportunity for humour in this environment. This kind of behaviour created a culture of telling on each other for

the smallest reason, so I found my group of trusted delinquents who broke dumb little rules with me, like chewing tobacco during movie time. Once, I was ratted out for breaking off my cigarette filters. However, I was already a chain smoker with that habit when I entered treatment. Fortunately, my friend, Ginger, who experienced the intervention was in the same facility, and she verified that I indeed did this before I arrived, so it was clear that it wasn't a new addictive behaviour.

Although I was called out for misbehaving every day, I was genuinely thankful for a safe space to work on my wellness. However, at one point, the owner accused every resident of treating the place like a summer camp. I believed she was talking to me as the ringleader because my counsellor often accused me of perceiving rehab as a summer camp. But for me, treatment was better than sitting in jail or dying in a park, and I was grateful to be there. But she was right—I didn't always take it seriously and often had fun. As a result, every resident was asked to join a circle in the auditorium one day. We were instructed to look at the person to our left and then to our right. After following those instructions, we were told, hypothetically, that one of the people beside us was already dead, having not taken our treatment seriously. At that moment, thinking of the stockbrokers seated on either side of me, I realized it was me who was guaranteed to die sooner than later if I kept using.

I lived where death was a possibility as it lurked around every corner. An old man from the streets once told me that my most dangerous enemy would be the one who fears me the most. By the time I went to this recovery centre, I had overdosed on my own several times and had two women hot cap me once; this is when someone overdoses you on purpose. Thankfully, my uncanny high tolerance saved me from dying. Through a fog, I remember hearing them ask if I was dead yet. I

didn't have evidence that they tried to kill me, and I wasn't sure if I was dreaming. Either way, I was close to death's door, and I learned never to allow anyone else to mix my dope, especially if they feared me.

We were told that the program wouldn't work if we kept secrets, and we had to be one hundred percent truthful, or the chances we would use again were high. I thought back to when I snuck the Ativan in and how my recorded clean time wasn't accurate. I considered disclosing my secret until one of my friends there shared that he had the same dilemma. I discouraged him from disclosing what he had done, but the guilt ate away at him until he told his counsellor. He was immediately kicked out. I was shocked because he didn't have the drugs anymore and was being honest, doing what they said by revealing his secret. I shrunk into myself while watching him leave as if walking death row—I knew I could never share my indiscretions with anyone if I wanted to survive.

I got through treatment, and when it was time to go home, I remember telling my counsellor I couldn't leave because I would surely die. I believed I couldn't continue changing my life if I went home because I couldn't get away from my people still living in addiction. Their response was that I couldn't run away from myself, and but I knew that I had to choose to leave my past behind, and that included my friends if I wanted to succeed. So, I asked to stay in the extended care support facility, which had some freedom and an agreement that I get a sponsor and go to a 12-Step program. Unfortunately, I picked the worst sponsor; she was a dry drunk—someone who maintains sobriety but still acts like a drunk within daily living. In addition, she was always too busy to help me, throwing dry parties for the men in the program.

I was assigned a new counsellor in extended care, a gentle

older man. He became my solid sounding board, and I still keep his wise words close. After six months of detox and rehab, I was told I had to leave and put my tools to use; I was terrified but knew I couldn't stay. To this day, I wish I had the polaroid picture taken during my first moments in rehab and never returned to me to remind me of where I came from.

I found a place with one of the girls in the extended care program. This was against the advice of my astute counsellor, and I later wished he had told me not to put the lease in both of our names. The first few months were uneventful, and I began considering getting some training for a future career. I started taking aqua aerobics and going for power walks. I quit my smoking habit because it seemed dumb to light up after my workouts and cigarettes went up to six dollars a pack. I also wasn't working yet and had no money. I considered becoming a massage therapist but learned there was a high burn-out rate. I love rocks and was always interested in geology, so I pursued that and went back to school to upgrade my science.

During that time, I met up with Carter, a guy I had dated before going to treatment. I was told he was clean and sober. He seemed to be doing well, and I enjoyed his visits. He got me flights to the mainland on a float plane to visit him—before I knew it, I was pregnant. I was 27 years old, and I thought I was mature enough to handle it. After being underweight most of my life, I never worried about getting pregnant because I hadn't had my period for most of my adulthood.

My roommate relapsed on crack, and I couldn't kick her out since we were both on the lease. She did all kinds of weird stuff, including holding a massive pink teddy bear while working the streets and coming home and using my toothbrush. Waiting it out until the end of our lease was one of the longest two months of my life because she also cooked crack on the stove beside me

while I cooked dinner. Our lease expired, and I found a new place closer to downtown and the end of the seawall. It was kind of a dump, but I was able to walk along the seawall and watch the harbour seals on my way to the bus that took me to school every morning. It was magical, and I looked forward to every morning and my new life.

However, being pregnant presented a new challenge because I was alone in the city with no family. I hated the 12-Step program—it reminded me of church; the God bits weren't the issue, but instead the feeling of confessing and the collection basket. I didn't really resonate with that community.

I was proud to finish my classes with an A average. Carter had cousins in Calgary, Alberta, and we decided to move there. I was figuring out pregnancy on my own, so moving didn't seem like a big risk. I didn't even go to a doctor for the first trimester because I wasn't sure it was necessary. It wasn't until I got the flu that someone indicated my high fever could negatively impact the baby.

Carter got a job as an iron worker, and we were doing okay. I became a telemarketer to get out of the house but wasn't planning on working very long and didn't want a job that required too much training. For me to use the one car we had, I drove him to work every morning at six o'clock. Then one day during our morning commute while sitting in a long line at a red light, I realized I was the stiff I had sworn I would never become only two years ago. I couldn't decide whether to laugh or cry. And although I was glad that I wasn't a heroin and cocaine addict anymore, a piece of me missed the excitement of it all. The next thing I knew, Cherry and her mom were in the city and offered me a job managing a new Red Affair location back in British Columbia.

Even though I had the intention of moving forward, I took

the job, not quite having made the distinction that it was unsafe to keep one foot in the past because I associated the Red Door with my safe place. We left Alberta on this new venture and set up our place, living on-site upstairs from the escort agency for free, which was one of the most attractive reasons for moving there. Carter looked after our baby while I worked. Managing the girls included a lot of drama, even though they were mostly nice and things went fairly smoothly...until I took my first three-day vacation and received a call indicating that the silent partner who had the business in his name had killed himself.

Business carried on as if he never existed, and I didn't miss him because he had interfered with business, often taking the girls out partying and leaving the shop short-staffed. A couple of months later, some guy walked in and claimed he had killed the owner. If I wasn't pregnant with our second child, I might have tried strangling this moron to death because he ruined my only three-day vacation in a year. He seemed surprised I wasn't afraid of him and that he only pissed me off because I went on a rant about having my holiday interrupted. I didn't believe the guy; there is always someone trying to take credit for crimes in an attempt to make themselves credible.

Another time, I received a bomb threat, and while I knew it was inconsequential coming from a harmless drunk, I recognized that my job raised my blood pressure. I reflected on what was important to me and realized I didn't want to raise my kids around hookers and gangsters. We decided to head back to Calgary, Alberta, where my kids' father started a business during the construction boom. I stayed home to raise our children and cared for an employee's baby while his wife went to work. I was not completely sober, being on the weed-maintenance program to help keep me off the booze and hard drugs. It wasn't until my two-year-old son started to roll a joint that I realized his little

mind was soaking up every detail of my behaviour. I decided we had to be more discreet about what we were doing because I didn't want any kind of drug use to be a norm for my kids.

I sometimes travelled home to visit my family, and life was good. However, I caught him cheating the year before and had trouble letting it go. For the most part, we were doing well, although we argued often over trivial things. I decided to go to my parents for an Easter holiday, and when it was time for the kids and me to come home, I called him to transfer money for the trip, but there was none—he had relapsed. I was stuck there with my two children and two bags; one bag was filled mostly with baby stuff and their favourite toys.

I chose to rebuild my life back home on the reserve without him. It wasn't easy, but thankfully my parents let me stay with them. I had to go on welfare, which is now called income assistance. I didn't have a lot of options with two babies, limited childcare, no education, and no work experience to put on a resume other than the delivery job from a decade ago. I was fortunate I had my parents to cover extra costs, helping us get by.

Then, a community member came to repair my computer one day and suggested I try volunteer firefighting. This was shortly after the 2003 wildfires, and I was driven to help in some way but had no idea how. It seemed like a good fit and opportunity, so I joined up for the training and experienced a long-forgotten sense of belonging. It was hard work, but the sense of camaraderie and purpose while helping others and being part of something positive was well worth the effort.

Soon after, I was asked to coordinate a community event called A Gathering. To qualify, I had to be on welfare and needed a car. I was the only one who met the criteria. It seemed too good to be true, so I was skeptical but took the job and excelled

at managing the project because I was organized and efficient. The volunteer committee oversaw the budget and guided me to find the right people and resources. It wasn't easy because I was constantly problem-solving and fighting for respect. For example, I had to pick up a deer from a hunter to be cooked and eaten at the event's big feast that weekend. He had left town that morning and told me it was in the garage. When I arrived, I found the whole deer hanging from a hook to bleed out. I borrowed my brother's truck, and a man from a neighbouring band agreed to help me get the deer down and cut it up. We figured all this out on the fly and got the meat to the traditional cooking pit just in time for the feast! It wasn't pretty but we got it done.

Ultimately, it was a successful three-day event with a traditional feast and daily breakfasts. There was also a powwow, stick and other cultural games, a horseshoe tournament, a Run for the Drum race, and many other activities. I was asked to run for band council a year later because I managed conflicts and the committee so well.

Then, I jumped at the opportunity when my captain at the fire department needed someone to help his wife clean houses for their company. I was grateful to work for them for many years; they were great people and bosses who invited my kids and me to spend many weekends at their lakefront cabin.

For the most part, I loved the job because it was like getting paid to work out. However, the one challenge I faced was that after I paid for childcare, I made less money than I did on welfare. Although I wasn't planning on making a career of it, I was thrilled to know I would have a real job reference and some work experience for the first time in my life, so the sacrifice was worth it.

I also had to worry about some pretty expensive things

in their clients' houses. One was a decorated ornament that looked like a Faberge egg but was only worth thirty thousand dollars instead of millions. I refused to touch it for two reasons: I didn't want my fingerprints on it in case it was stolen one day, and I didn't want to risk breaking it. Every time I left that place, I prayed for the safety of that home.

I loved everything about firefighting: the training, the people, and the calls. However, I believe one gift helped me stay sober and out of trouble—the adrenaline. The only thing I missed from my old lifestyle was excitement. Even before I became an addict, my childhood gift of post-traumatic stress was the need for speed and an adrenaline rush. So, in my teens, I became an adrenaline junkie and got my fix downhill racing at the ski hill. When I got my driver's licence later, I used speeding in my mother's car and living on the edge doing all kinds of other crazy and dangerous things to meet this need. Later in life, my mother told me she had considered buying a place on a nearby ski hill when I was young. I wondered how different my life would have been if my desire for adrenaline had been met in a safe and positive environment. As a firefighter, I legally received this rush while helping people. I could give back to society and hoped it would provide some good karma to compensate for all the wrongs I did in the past. Volunteering was fulfilling, going to schools for safety week and providing first aid at community events. I developed a sense of worthiness and discovered I was further healing myself by helping others. Eventually, even though volunteering was initially driven by guilt, it became a passion.

It was good to be home and reconnect with the members of my community. My cousin offered me a job at a weekend conference because she needed support to get through the project. She was publishing a book of stories written by

elderly indigenous women who attended residential schools. The weekend included facilitated circles with the storytellers and a debriefing session after they shared what it was like to write their stories and their most intimate experiences with the scribes.

One woman shared having been sexually assaulted at the hands of a nun. She was an 80-year-old woman voicing her pain for the first time and spoke about how she had hidden this story from her loved ones her entire life. At that moment, I realized that I couldn't imagine living that long in silence and how important it is that everyone shares their story. With every word she spoke, I saw a piece of weight lifted from her shoulders. I hold that memory close to my heart, even though it was painful to hear.

Another woman spoke about how residential schools affected her parents' ability to parent positively and how she subsequently parented. She shared the domino effect of how the abuse that occurred down the line negatively affected how her children parented. She spoke about the need to change past patterns, and as I listened to her, it was as if someone was handing me the pieces of a puzzle that made me whole again. I always knew something was missing, and until that moment, I didn't know what it was. This weekend ended up being a life-altering experience for me.

At one point, alternative healers were brought in to introduce the storytellers to new healthcare methods since many had forfeited modern medical care after being abused by doctors and dentists in residential schools. As workers, we could pick two sessions if there was time after all the participants had experienced theirs. I chose an Indian medicine woman, and as she worked on me, she listed the abuse I survived and mentioned that she believed it was too much for one person.

She reached around me and explained that she was bringing the pieces of my shattered soul from the abuse back together again. It took her a long time as she powerfully connected each part, making me whole again. She explained that my back pain reflected the boxes of Carter's things that I needed to get rid of. I immediately asked him to take them back when I went home.

Armed with knowledge and inspiration, I was ready to work on myself. However, I wasn't prepared to tell my whole story to strangers. I held onto a lot of shame, still believing I chose a lifestyle I couldn't escape. Shame continued to grow inside me as I faced society and all its expectations as a sober person. I wanted to hide the uncomplimentary parts of myself because I still struggled with my past and didn't think I would ever fit in or be accepted into this side of society. However, I also believed it was integral to tell future partners all the sordid details about who I used to be. My friends discouraged me from doing so, but I didn't want to hide my past from those close to me—I prefer to be honest instead of worrying about my past resurfacing.

It was exhausting hiding my past and not openly talking about it with people outside of my close inner circle. Some people in the community spread rumours about me, but there was nothing I could do about that other than take control of my narrative. I was desperate to leave that part of me behind to make space for a better life for my kids and me. And being back on the reserve with my family was a welcomed change and healing process. The close tie from childhood was still strong with my cousins. In our culture, we consider first cousins to be as close as siblings can be. Mine were there for me, and we continue to be friends.

I continued to deal with my shame and worked on managing my rage as a parent. It wasn't going well—I was

no longer smoking weed since I returned to the reserve and began realizing it had been a temporary tool to supress my anger. I wanted to be a better parent but couldn't handle the responsibility on my own. At one point, I went to anger management classes, and they were helpful but didn't offer the level of skills I needed. The life I came from included people doing what I said, and now, I had kids who didn't seem to give a damn about what I wanted. They were wild, and I didn't know how to manage them. I spent as much time as I could volunteering at the school they attended because I didn't trust anyone to look after them and sending them to school was difficult. And yet, I screamed at them in an attempt to get them to behave. Although I was grateful for no longer being a drug addict, I struggled with my inability to parent effectively as a woman with little patience at that time. I resented myself for being a horrible human being and making their lives worse instead of better. My only solace was that I was maintaining my sobriety and attempting to learn how to self-manage.

Years later, I realized my temper created chaos and made my children anxious, and I didn't want them to be afraid of me. They went to school stressed and couldn't focus on their lessons. The more I learned about my kids and how my way of being affected them, the more I learned how to parent lovingly. It wasn't a perfect transition, but I discovered that when I calmly outlined my expectations, they became calmer and wanted to meet them. This process took time, and even a decade later, my kids continued to teach me how to be a better parent and person.

There were times when they got upset and I became defensive and argumentative. My teenager asked if I preferred that they sulk and bottle things up. They showed me my shadow self, the person I didn't know existed and who shut people down to

not have to face my guilt. I went back to the 12-Step program but left the meetings in a state of depression, and I didn't want to live like that—no one seemed to be having fun. I listened to people quote the Big Book and other colloquialisms. They confessed their relapses, having to start from day one again and beat themselves up. I couldn't relate to counting days and reliving my addiction stories; I was done with that life and had goals. It wasn't that I was managing perfect sobriety, but my reality was that I had two kids to look after and I couldn't risk drinking and driving. As it was, I was lucky I never got a DUI or killed someone or myself in the past. So, I gave up on the meetings and went to counselling instead—that in itself was an experience.

Prior to this, I was asked to run for band council. I didn't know exactly what I was getting into, except that it was a two-year term. And, although it seemed like an eternity, I accepted the challenge and ran in the election. As this moment, I suddenly believed my life wasn't over. I used to think I would die by the age of 29, but for the first time in a while, I felt young again as a 32 year old in politics. I was successful and so excited to be on this new journey. However, when I went to my first meeting, I was surprised at how boring it was. I sat there in stunned silence, regretting that I had to do this for two years! I already suffered from ADHD, so having to sit there for three to four hours once a week seemed like a new version of torture.

However, I persevered, and the job took over my life in a good way; I loved it. It was a new world filled with litigation, conferences, networking, and supporting new opportunities for our community. I was like a sponge with all the new information, and as a result, I received more opportunities to connect with our culture and learn about our history as I worked towards a brighter future for our people.

I was thrilled to join a variety of committees and continued to focus on my responsibilities as a councillor. However, there was a downside with all my time being devoted to this job—the community did not have boundaries. People called me at all hours to complain and stopped me in grocery stores while my four and six-year-old children ran loose in the store; I prayed they weren't stealing candy from the bulk bins or getting kidnapped. I couldn't eat without being interrupted at a restaurant, and my food was often cold by the time I ate it. My new boyfriend, Stan, and I either waited until later in the evening or travelled to the next city for dinner. People were persistent, so when they couldn't get a hold of me, they called my mother and passed their message to her. Despite these inconveniences, I enjoyed the job and was on top of the world in my new relationship. Until we broke up…

I was angry, realizing I had invested in a dream instead of reality. I concluded that my relationship consisted of me having a fantasy that he couldn't live up to. I wondered if others faced this issue as well. We were on separate paths, and I decided to leave him to date another guy who offered what I thought I wanted—someone who would invest in my children's lives and be part of my family. The only dilemma was that he needed a lot of attention that I couldn't give him, and then he cheated on me, so I left him too.

I was single heading into my next term on band council, and I began going out to nightclubs once my kids were tucked in bed at the safety of my parents' house. I reverted to getting only a few hours of sleep, which I believe is part of my genetic makeup on my mother's side—my cousin often told me, "Sleep is for the dead." Honestly, I think it has something to do with my undiagnosed ADHD.

While away at conferences, I went out after the meetings

to play pool or dance all night instead of returning to my room. All this time, I had no desire to drink. Over a decade earlier while partying with the girls from The Red Affair, I was paranoid and had hang-ups, so I refused to dance. My friends dragged me out onto the dance floor, but I was inhibited by my need to be a badass and barely moved. But being sober now, I had no fears or inhibitions and was free to experience the joy of letting my body move to the music.

While on the road, I relished in men's attention. Once the Blackberry phone came out, I was one of the first to get one. I didn't realize that its messenger feature was not just a valuable tool for business communication but was also all the rage as an effective dating tool. I needed it for work to google Latin words from legal briefings and research other things, but I also used it to message back and forth with guys I met on the road. These guys were perfect for me because I saw them now and again but never in my hometown, so no one there knew. This was a preferred arrangement, void of drama and with all the freedom I needed when I was back home. Unfortunately, that liberty fed my old pattern of unworthiness, my old sex addiction, and feeling out of control. I was once again drawn to men who developed what I thought was trusting relationships with me but ended up including and normalizing more abuse.

I haven't spent a lot of time reflecting on why I find certain men attractive. Throughout my life, I've been drawn to those who are emotionally unavailable and tend to be violent. That violence was often normalized, and I didn't believe I was worthy of being treated with kindness. Mostly, I thought I could handle them, and the trade-off was usually a drug supply. I viewed the men I associated with during my days as a drug addict differently because they were violent in a way that provided me with the security of believing I was protected. It was almost

like having my own bodyguard, who I could trust with my life, especially since I was running from a murderer. Although most people would find them scary, I found them enticing.

I have a theory about dangerous men: there is the possibility that they are created from childhood trauma, but I think they are remnants from old times when gladiators and soldiers were celebrated for being ruthless. They are descendants from a time when human rights weren't even thought of. As a result, they had no choice but to be cutthroat in order to do what was expected of them to protect their people. I read that trauma can be passed down genetically, so it makes sense to me that the disposition of the gladiators and soldiers could also be passed down in its unique genetic form. Back then, these men established an honoured and revered place in society. However, that way of being is not within our current behavioural standards because we understand the damage that violence and abuse create. Although the men I loved didn't usually harm me, the way they treated me wouldn't be considered a "normal" standard in today's society. However, I needed to feel safe, and I had that sense of security with them by my side.

These relationships were complex, and I often traded my need for respect for my need for approval. There are men who caught my eye much like Damien did when I first met him, but I wouldn't accept them unconditionally as I did him. For example, a man caught my eye once at a conference. He was native, handsome, and strong; he seemed important but not a chief type. I watched him confidently walk around, and I could tell his work was significant by the professional way he took his phone calls. He caught me staring at him at one point and came over to sit beside me. I'm unsure if we exchanged numbers, but I was suddenly called to a meeting in Vancouver and had to get on a plane that day.

Arriving at the airport, I got in the security-gate line, and when I turned around, he was walking up behind me. We exchanged some quick words about it being a small world and coincidences. When it was time to load the plane, he left when his section was called, and I waited until the final boarding call because I don't like being crammed on a plane with others in the aisle. I walked up to my seat, and there he sat beside mine. There were only two seat selections available for me when I checked in, and I happened to pick the one next to him. We laughed and got ready for take-off, and when I sat beside him and looked into his eyes, I instantly knew I was in trouble.

VII

Evolution

The seed is planted.
A sprout reaches for the sun—
new leaves to unfold.

We sat next to each other on the plane. In another setting, it would have been impossible to get any closer. I can't explain the connection I experienced. Being smitten by Lucky from the moment I saw him, I'm sure my magnetic attraction was obvious every time I looked his way during our short 40-minute flight—it didn't take long before he leaned in to kiss me. I didn't hesitate to follow his lead. Shortly after, he told everyone on the plane that we had just met, and he was picking me up. He was funny and quirky, but he could be a jerk because he was so cocky.

I often travelled back and forth to the city for work, so we did not visit each other unless I was there. This relationship was based solely on physical attraction. My teenage sex addiction resurfaced, and although I wasn't aware of it at the time, it was accompanied by an underlying sense that my life was out of control.

I was entering the next phase of my life and didn't have a plan. The world of politics doesn't provide job stability. Decisions aren't always made based on popularity, and the level of confidentiality required at the table didn't give me the freedom to justify those that created conflict. The levels of stress and conflict were intense, and at times, the council received threats—a barrage of angry phone calls and complaints with people yelling so loud that I didn't need to put the calls on speaker when resting the phone on my desk. Nevertheless, I was committed to the job—it was often difficult but still easier than what I had survived on the streets.

One of many things I repeatedly heard in treatment and the 12-Step program is that people become emotionally stunted when they start using. This was even more prevalent for me because I used emotional blocking to cope with my abuse as a child and throughout my addiction. Other tools I used in the political arena were the survival techniques I had learned over the previous decade: managing people, diffusing hostile situations, and being assertive. I still had anger issues and was prepared to escalate any situation to fight my way out. I believed I was achieving something and wanted to achieve more, but a shadow of doubt haunted me.

Lucky became my new drug. Although I managed to stay off drugs and wasn't drinking anymore, he became my replacement for substance abuse. Willingly subjecting myself to more sexual abuse, I received the adrenaline and ecstasy I craved. However, I simultaneously cycled through shame and resentment—for him and myself—as I turned my power over to him time and time again. He didn't care what I did and expected nothing from me; I believed he was the perfect man for me.

Adrenaline helped me block my reality, and my old tools

supported me to block new uncomfortable memories I didn't want to imprint on my brain as the escalation of roughness increased. I automatically utilized my defence mechanism of blocking emotional pain by continuously normalizing abuse as a form of affection. Other than fulfilling my longing to be with Lucky, I didn't understand why I kept returning for more. I knew he wouldn't provide me with the love I wanted in a lasting relationship, yet I willingly invested the time and energy required to meet his demands. We didn't have boundaries, and I reached my limit when he threatened to invite outsiders to our sexual encounters. This was a dealbreaker for me, and although I didn't want to leave him, I was beginning to lose trust in him. I was done and finally mustered up what little self-respect I had and left. I never went back.

At this point, I struggled to manage my personal life, including my sobriety. However, I was professionally successful and became aware of others making legitimate incomes; I saw what real opportunities looked like for the first time in my life. As a politician, demands on my time were high, and I continued to struggle with my self-image. I sat all the time, which was a big difference from when I was a firefighter and had a regular workout routine or when I was a physically-active house cleaner or server. So, I began to gain weight and decided to change my diet and consume less food to lose it. Some of my colleagues expressed concern when I dropped close to 20 pounds in a month, but I assured them I was eating a lot of food, and I believed I was; I drank protein powder with water for breakfast and ate low-sugar vegetables in the morning until I was full. I allowed myself one meal at four in the afternoon and an apple or three graham crackers for dinner. I felt like I was in control of my body again and was convinced that food wasn't meant to be enjoyed.

My daily 1,100-calorie diet didn't help me manage the deep-seated rage that continued to burn since my teenage years. I didn't know how to keep it in check and lost my temper over the smallest things. For example, my kids accidentally locked me out of the house once, triggering memories of my boyfriend or my friends locking me out when they were high. I frightened my children, erupting into a tirade while kicking the door and screaming. I then crashed into a state of self-loathing and begged them to forgive me as shame and disappointment enveloped me. I struggled to get through each day and worried I would end up with an assault charge one day. This was mainly what motivated me not to drink.

I used tools from my women's anger management class, such as learning to take responsibility for my choices instead of feeding into the message that I am a victim. I had already worked on this effective approach to self-management when I was in treatment. However, I found that this group catered more to the average person's anger rather than the level of trauma and rage I was experiencing. I wondered if the model for a men's group would have been more effective for me.

Being accountable positively affected so many areas of my life, especially since it allowed me to become aware of the red flags that come up when I pursue relationships. I was a child when I was initially abused and never asked for help. This was the result of having valid trust issues. However, I didn't blame myself; I just believed that no one could help me, so I didn't advocate for myself. Consciously working on myself as an adult, I gained the understanding that I could make different choices that provided positive relationship outcomes. I then applied this practice to all areas of my life and became less angry. At first, it was difficult to look at myself in order to take responsibility for my decisions. But with time, it became easier

to choose a better way of being—one that resonated with who I really am. I realized that there aren't necessarily good or bad decisions but instead choices that have consequences. I also discovered that I could deal with those consequences, and when I did, I was empowered because I took responsibility for myself. My epiphany was that I needed to focus on celebrating when I chose to do better rather than beating myself up for making decisions with adverse outcomes.

Sleep was never easy for me, and I only got about three to five hours a night during this time of self-work, so I wasn't functioning well. Initially, I didn't seek medical advice and spent many nights crying myself to sleep, reliving my countless trauma stories. Finally, someone suggested I seek counselling, and I looked forward to getting support since I was committed to change. However, this became a challenge I didn't expect.

My first counsellor wanted to know everything I did during my addiction, so our sessions felt like a research-project interrogation. I shut down every time we met because I wasn't receiving the help I needed. My next counsellor let me know that I wasn't alone and took a different approach, recounting personal stories that mirrored mine. Each time we met, I talked about my past trauma that I was trying to emotionally manage, and she then recounted tales of similar events she experienced. She matched or one upped my story no matter what my trauma was. I felt like I was in a competition with her and didn't believe I was getting the help I needed.

She also introduced Eye Movement Desensitization and Reprocessing (EMDR) therapy, and while others swore it was an effective treatment, it made my PTSD worse. I wasn't ready to relive my trauma through EMDR therapy because it brought up new memories, and I was confused about whether they were real. I started having breakdowns when I was alone

while screaming into my pillow and punching the bed instead of the wall so I wouldn't scare my children. Crumpling in a heap on the kitchen floor during my evening chores, I cried for hours while my they slept. I decided to give myself a break from counselling.

Then, I found a new counsellor through one of my children's support groups. She usually only worked with children but agreed to take me on. She listened and challenged me to focus on what was going on today rather than my past. I talked about my rage and how hard I had to work to remain emotionally calm. I told her I was triggered by scary, suspenseful, and sad movies, so I only watched comedies and action. I shared how exhausting self-management was, and then she shared something about my rage and PTSD that made so much sense...

When envisioning an empty versus full glass of water of negative emotions, people who haven't experienced the level of trauma I have begin with an empty glass as the starting point of a daily functioning state of calm. As the day goes along, this person needs to fill the entire glass with negative or uncomfortable emotions beginning at that empty line to achieve a state of anger. However, people with PTSD start every day with the glass already half full of rage. As a result, it takes less time to fill the glass and manage their adverse emotions than the person beginning with their empty glass. I resonated with this because I realized my constant state of hypervigilance to manage my emotions far exceeded the same of those not suffering from the effects of past trauma. Self-awareness became the key to avoiding the rage button.

It seemed so simple now. I had been operating in survival mode for so long that I was completely unaware it was happening. I recognized that I needed to work on my emotional

intelligence, which required the need to be mindfully aware of my emotions and how I react to them. I didn't even know that this concept or term existed, but with a lot of work and reflection, I could understand my anger's origin to determine how to respond to it authentically. It didn't happen overnight, and of course, I didn't eliminate it, but I no longer felt like a raging psychopath. I learned how to slow down my mind and communicate differently—I finally put my anger management class tools to work.

Within all this progress, I had other developed patterns to tend to. One was believing that I needed to be normal, or at least look normal for public perception. I started dating a man I really liked. My kids got along with him because he was fun when he wasn't working long hours. The relationship seemed perfect at first until his ex-wife made up lies about my kids and shared them with their kids. They had a relationship filled with conflicts, and I couldn't understand why the man in my life couldn't set boundaries with his ex. It was the source of frustration and our arguments at times. He was recovering from addiction and held onto a lot of shame—I thought he lacked confidence in his ability to advocate for himself.

Over time, I realized that we approached life differently; he expected a declaration of love within six months of starting to see each other, and I thought it was too early for that kind of commitment. After our relationship ended, I read The Five Love Languages by Gary Chapman and determined that mine is a combination of spending quality time together and words of affirmation. I don't value the expectation to express love within a timeline. However, I also don't take being committed to someone lightly.

I thought I was giving him freedom, but he was insecure and believed I was pushing him away, so he began to get

suspicious. Unfortunately, I didn't see the level of unwarranted mistrust getting better, which eventually turned into a jealousy of something that didn't exist. When the conflict escalated, we ended the relationship. Although disappointed, it was clear to me that I wanted a partner who added positive value to my life. Dealing with jealous boyfriends when I was a teenager, I remember my dad telling me that jealousy is a disease without a cure. I hold that saying close to my heart because I agree; being envious doesn't bring people closer together, and if it doesn't push them apart, it becomes a shackle creating a prison-like environment.

After two terms, the election was looming, and I knew my time was limited when the vote for a community initiative I supported failed. I was devastated about not being re-elected but became easily distracted when my cousin died around the same time. We grew up together as teenagers throughout our school years and developed a bond through addiction—we were very close. This death sent me reeling into depression. I cried all the time, finding myself suddenly unable to stop sobbing while washing dishes or driving.

My children were involved in many activities, so I was busy driving them around, which kept me going. After six months, they asked when I would stop crying, and I thought it might be time for a medical intervention. I tried anti-depressants, but one day I realized I needed tools to get through my grief instead. I didn't like being dependent on medication to function. I wasn't ashamed, but I was afraid I would forget a dose and taking the pills caused more anxiety than support. It was the right decision for me.

With my short career in politics over, I began looking for a new job and realized that I needed to meet the societal demand of acquiring formal education. Unfortunately, as

a single mother who wanted to live close to her extended family, my dream to be a geologist was unrealistic because of a lack of local opportunities. It was difficult to give up on that goal, and I still craved knowledge, purpose, and fulfillment. I decided to work toward my Bachelor of Business degree and put aside anything that might get in the way of focusing on my education, including relationships. I envisioned myself in a career that supported corporations to establish new stores in various cities, and that became my study concentration. I knew my success depended on more than a degree, and I was willing to put forth the effort.

These new goals inspired me to leave negativity behind and work on my future to provide a better life for my kids. It had been ten years since I went to treatment, and I realized that I am an observer and not everything was about me. So, when I initially join a crowd, I watch everyone quietly. I had been observing people around me for years and decided not to take things personally, allowing others to take ownership of their lives. It became clear that everyone has issues, but very few had anything to do with me. This clarity raised my confidence, so I looked forward to walking back into the education system. However, I had lost some confidence in my ability to learn since being out of school for the better half of my life. Initially, I thought I was too old, but I had no choice if I wanted a better life.

Going to school as a single mom gave me the flexibility to parent my kids while meeting my goals. I continued working for the cleaning company but now had janitorial contracts for buildings; I preferred them to houses. As I expected, the whole process of combining school, work, and parenting was difficult, and as the years passed, the classes got tougher. However, the gradual progression of difficulty was a welcomed relief. In

addition, my Council experience helped me understand the purpose of the curriculum and how to apply it to managing the stress of every facet of life.

I committed to swearing off men for a while. It was relatively easy because I was 37 and the average age of a college guy is 22. When I was using, my mother often criticized me for not finishing anything, which was another incentive to focus on school and the reason I was going. I wanted to see this goal to the end. However, obtaining my education proved to be a difficult task because I struggled to keep up with the pressures of school and my maternal responsibilities. I was back living with my parents, who were now in their 80s with failing health. They were helpful but also needed me and became an additional demand on my time. My mother experienced some breaks due to falls and had difficulty completing daily tasks as simple as peeling a banana. My father was heavily reliant on someone bringing him food due to his blindness, and I often ran home between classes if I didn't have time to prepare food for him before I left for school. My siblings helped, but the daily chores were difficult to maintain. I realized that I might not have them around by the time I turned 50, and it was vital that I do the best I could to support them. So, I reduced my course load to look after everyone, including myself.

My mother was 43 when she had me. As a teenager, I wasn't too compassionate about her situation. However, once I had children, I had much more empathy and thought about what it would be like to have kids in my 40s; I suddenly understood how difficult it was for her. I couldn't imagine how my parents managed when I initially disappeared overnight and then for weeks and months. Without the invention of cell phones, or the luxury and expense of long-distance phone calls, they sat in endless worry, never knowing where I was or what

was happening to me. I think this was the norm for parents in the nineties, but knowing I was struggling with addiction must have added to their stress. Now, being a parent myself, I was filled with overwhelming guilt. I beat myself up, moving through the merry-go-round of ups and downs between the regret of my youth and the comfort about where I was headed. I eventually realized that in order to move forward, the one person I had to forgive was myself.

Someone once told me that I also had to forgive my abusers to move on from my childhood trauma. I immediately rejected the idea, being so enraged at the thought of absolving their wrongdoing when they didn't seem remorseful. I wondered how this would help me, and I held onto my rage. I decided to start with myself, asking for forgiveness whenever a regretful memory surfaced. During the short time I participated in the 12-Step program, I learned that I needed to right my wrongs, and when I didn't have the opportunity to make amends, I needed to actively right my wrongs to achieve something for the greater good. For example, I volunteered by helping at events that supported United Way projects.

Although I had reduced my school workload, I still had the demands of being a mother and caretaker to my parents. My children were also active in sports which involved a heavy schedule of practices and tournaments. I was often burnt out, trying to provide a perfect life that included homemade treats and bread. I stayed up late doing homework and was still firefighting and maintaining a bit of a social life. I often pulled up to the house and sat in the car crying as I struggled to find balance. There never seemed to be enough time in the day, but I wanted to accomplish my dreams, so I pushed on.

I had recently attended a funeral for a firefighter from a neighbouring jurisdiction, and then after one particular call, I

realized how dangerous fighting fires was. I had just completed working through the night and went directly from the call to the college to write an exam in the morning. I was weak and exhausted, having had no sleep, and I barely passed the test. I reflected on how important firefighting was to me, given my focus on being healthy and achieving my goals. However, because I was so busy, I couldn't attend many fire calls, and I often didn't have childcare. As a single parent, I also thought about the risks of the job and whether it was worth the possibility of getting hurt or worse. My kids' father struggled with brain injuries and addiction, so I could not rely on him if something happened to me. With great difficulty, I decided to give up firefighting, even though it only freed up Tuesday night when the fire department had practice. Eventually, I also quit going to the gym because it was just one more thing for me to fit into a day.

Even after these attempts to find balance, the everyday demands of taking care of everyone were overwhelming. I found a place in town with my kids and moved out of my parents' house. My goal was to give my children independence, but I was simultaneously fearful that something would happen to them. I think all parents go through that transition, but it seemed worse for me because of what I went through at their age.

If my kids were late getting home, I panicked and tried to calm myself down with positive self-talk, but I was mostly unsuccessful. My children were my driving force to achieve a better life, and I needed them as much as they needed me. So, I raced through the streets with terrible thoughts running through my mind as I tried to track them down. The stress began to trigger my PTSD, and I couldn't sleep without the house deathly quiet. I started arming myself, sleeping with a

knife wedged between my mattress and box spring. I placed large rocks near the door and carried knives and pepper spray. Every sound had me on high alert, and I couldn't achieve the necessary REM sleep I needed because every creak the house made woke me up. My counsellor attempted to convince me that I didn't need the weapons I carried and had hidden in my house. The best I conceded to was putting the knives in the drawer.

During this same time, my commitment to stay away from men quickly ended, and I struggled with my sex addiction again. Smoking weed followed. I began avoiding life, falling into a depression, and getting by on the bare minimum. I ended up hooking up with a guy whose place became my stress getaway as I visited him any time I could and when I had a break from school. In reality, I didn't really like him and liked him less when he spoke. We actually got along best when we weren't talking. This continued for years while I was in school, and then one day, I realized I didn't like that my daily motivator had become the joint I smoked when I got to his place. I chose to quit both him and the weed.

Once again, I struggled with my weight and returned to my low-calorie diet—many would have described me as anorexic. I returned to the gym and added hiking and yoga to my daily routine. I believed I was back on track and felt good about myself. However, still in school, it became more challenging for me to make ends meet, so I accepted a summer job as a human resources assistant on the reservation at the band office. I enjoyed the challenging work, which included writing a grant for a policy project. It was successful, and my supervisor encouraged me to apply for a policy development job, and I got it.

With this new job, I had to reduce my course load again

to two classes per semester. As a result, I took summer classes hoping to complete my degree in six years instead of four. It was hard to push through, and I considered quitting and walking away with just a diploma more times than I could count. Even though I knew getting a degree would make a difference, the prospect of going to school year-round to complete ten classes without a break made the possibility seem bleak. Then one day, one of my professors asked how I was doing, and I confessed I was struggling with how long it was taking to finish my degree. I felt defeated because all my classmates were graduating without me. She shared that it took her eight years to get her degree, and no one ever said it had to be done in four. As a community college professor who taught me just one class, she was willing to mentor me. I'm not sure that would have happened in a university, so I was grateful for her advice, which inspired the epiphany that I was comparing myself to 20-year-old students without kids to support.

Other temporary opportunities opened up, and within five years, I was given several positions: council secretary, human resources manager, economic development officer, and executive director. I was assigned to numerous regional committees and became acquainted with countless community professionals. I worked hard and didn't turn down any project, determined to prove myself. It wasn't a cakewalk, but the trials and tribulations were worth developing a professional reputation and creating a positive internet footprint.

Unfortunately, while reaping the rewards of my career success, my ongoing struggle with managing the pressures of my personal life continued. One day, while complaining to an older woman I knew, I shared that I thought life would be easier on this side of the needle. She responded that an easy life is never promised, and right then and there, I decided to

be the person who calls someone who might need a listening ear. My intention wasn't to find a shoulder to lean on but to see how they were doing. There was rarely a time when the person I reached out to wasn't struggling with something, and I forgot mine by listening to their problems. At that time, calling someone when I felt down often released me from of a state of self-pity and put what I was dwelling on in perspective because sometimes it seemed that other people had bigger problems than I did.

I reached my goal of finishing school after six years and was burnt out. One day, after putting in long hours as the interim executive director, I decided to do a load of laundry. When I'm exhausted, my obsessive-compulsive disorder kicks in, and I do chores that can wait. I might be unable to stand up but will still choose to start picking weeds. I can't seem to stop until they are gone because, well, that's OCD. On this particular night, I was washing sheets, and there was no reason it couldn't wait a day, but I couldn't get them off my mind and decided they were getting done. As I made my way downstairs to put them in the dryer I fell—really hard. Lying on the stairs, I screamed in excruciating pain and couldn't move my left side, so I called out for my kids. Unfortunately, they had their headphones in and didn't answer. Realizing I could be there all night, I thought about the irony of the soundproof basement I loved until this moment.

As I lay there, I slowed my breathing and tried to move. Realizing I hadn't broken any bones, I slid down the rest of the stairs and pulled myself up. The first thing I did was dry those sheets. Once I limped upstairs and lay on my bed in agony, even though I thought they were justified, I fought back my tears of self-pity. My pride stopped me from calling an ambulance, and it took a couple of weeks for me to discover I had a concussion.

I remembered hitting my head but wasn't experiencing the list of concussion symptoms I had in the past. However, the obvious red flag was that I couldn't remember what I said the day before, and after two weeks of sitting at a desk, I was in excruciating physical pain from having banged up my body and had to take time off work. I resigned as the interim executive director but retained my position as policy analyst.

After months of not moving, I finally got back on my feet. It was a difficult recovery because my spine hurt every time I moved. I went for short walks to visit people and lamented to one of my friends how something so bad could happen to me after working so hard to change my life around. Then, incredulously, he asked me, "Wait a minute, you think because you're doing good things, only good things should happen to you?" I wanted to say yes but realized how entitled it sounded, so I responded, "When you put it like that, it sounds stupid."

When I finally returned to work, there was a new executive director. I tried staying out of the spotlight because I heard he was a tyrant and focused on my policy analyst duties. However, my new boss was told I would be an excellent resource and found me after three months of sticking to myself. He was in a term position, and when his contract expired, he signed a new one to build the business arm of the organization and find a permanent CEO. He was excellent to work for and I enjoyed learning from him. I decided he was the kind of supervisor I wanted to be. So, I supported him on a project to create a business-development arm for the organization. It was a big challenge, and I was excited to take it on.

Not long after, my father died, and to respect him my family followed cultural protocols while making his funeral arrangements. In our community, we hold the wake in the home where the body is brought to rest. We serve food, hang

cedar bows, and cover the TV and pictures on the living room walls. Every night, family members take turns sitting with the body to pray or simply so their loved one is never left alone. As part of the protocols, visitors surround an outdoor fire throughout the day and night until the last shovel of dirt is laid on the grave. Hundreds of people are often in attendance, and a huge meal is provided after the funeral.

It was a crazy week because I had to get my daughter back from a remote field trip. At one point, I was sitting in a car on the side of the road, booking flights on one phone and arranging to have my aunt and uncle pick her up on another. Next, I called her teacher to confirm a ride was coming. We didn't have much time, and I made the arrangements in less than an hour. It was overwhelming, so I went to my nieces and took a moment to sit on the floor to take a breath. When my daughter arrived, I was happy she was home! I was grateful when one of the elders approached me to share that we did a good job. This meant everything to me because she doesn't often share her approval. I took a week off and returned to work with a load of responsibility waiting for me. People encouraged me to take more time, but I dove right back into work.

A new CEO was eventually hired, and he was the opposite of any bosses I had in the past. I wasn't used to being micro-managed, and I was unhappy. We got along outside the office and at conferences or social outings, but it was a different situation in the office. I still struggled with excruciating back pain, and nothing helped it. Every day after work, I went home and slept for three hours. I was in too much pain to cook and often resorted to eating microwave popcorn for dinner. Thankfully, my kids were now old enough to fend for themselves.

My mother was dying, and I wasn't as stoic as when I lost

my father. I thought about how my life would change after losing both my parents, and I realized I didn't fully grieve my father's death. To make matters worse, I was stressed as I moved to another residence and simultaneously devastated when it suddenly hit me that my mother would be gone soon. Then one night, while driving home from the hospital, I selfishly whispered a request for her to give me one more week. She died exactly one week later. I finished my move, and then lay in bed for a week crying.

My relationship with my boss declined further, and an attempt at mediation did not go well. My back pain was not improving, and I worried I might end up in a wheelchair within a decade. However, I convinced myself to go to work with a positive attitude, but the results were the same at the end of the day. I became resentful after reflecting on everything I had been through, still ending up in this place of being unappreciated. Then one day, I thought, "Screw it," and I gave my notice and quit. I didn't have a plan but knew I wouldn't take shit from anyone anymore.

VIII

Growth

Fight for survival.
The feast of vultures on bones—
a savage kingdom.

Relief swept over me as I walked out on my last day. However, twinges of guilt surfaced when I thought about leaving behind one of my co-workers. It was strange not having to report to work every day, but I embraced the opportunity to enjoy the rest of my summer and work on my health. My back injury recovery was slow, with increased pain and diminished mobility, and I was concerned I would end up in a wheelchair within a decade if I didn't make some changes. COVID-19 was new on the global scene, and restrictions closed pubs, restaurants, many shops, and fitness facilities, so I decided to grow my food and feed myself by getting a plot at the community garden with my cousin! We had a few wins along with many failures as we envisioned my ancestors guiding me through our gardening endeavour, providing intuitive knowledge on producing a bountiful garden—they never showed up. Nonetheless, we had fun as we reaped the therapeutic benefits of digging in the soil,

being in nature, and working together to produce something. It was also fulfilling to physically cook and enjoy the food we grew in our kitchens.

I sometimes sat alone in the sun on the garden bench that overlooked the lake and appreciated the beauty of the serene setting. During these mindful moments, I focused on life's simplicity—it was wonderful to just be within a moment of peace without outside demands, timelines, and pressure.

Part of my renewed commitment to health was going for a walk every day, and it was painful at first. Initially, I could only finish eight blocks, but I made a goal to increase my distance by one block every week. With time, I became stronger and practiced yoga every day, which became a priority since completing my yoga teacher training that spring. The more time I spent doing yoga, the more relaxed and peaceful I became. I gave myself space to grieve my parents and be thankful for my time with them. I knew I was fortunate because not everyone's parents live into their nineties, so being grateful was a good way to process my grief. I regretted the years I lost with them during my addiction and committed to not taking people for granted anymore.

Reigniting my gratitude practice allowed me to maintain a positive outlook on life. I began acknowledging moments of gratefulness around 2010 while simultaneously and frequently practicing yoga. After over a year of complaining about my boss and our tumultuous relationship, I knew I had to change my attitude. The more I reflected on my decision to leave, the more I wondered why I didn't leave sooner. The biggest lesson for me was that I always have a choice, and I didn't make the decision sooner because I was stressed and living in fear of losing the security of my nine-to-five job. In turn, this added to my back pain, elevated my negative attitude, and increased my

indecisiveness. However, as soon as I let go of that false sense of security, everything in my life became better. Alongside my newfound positive attitude and with the support of meditation, I became calmer and more grounded—people noted how healthy I looked and acknowledged the changes I was making.

I began reflecting on my life and my plan to write my memoirs, even though I wasn't convinced I had a story worth telling. And yet, when I shared my story with people, many were moved to tears and others insisted I write a book. Even still, I wasn't ready, but I knew I was getting closer. Now that both of my parents were gone, I could consider it because I didn't want my parents to read my story. I wanted to spare them the details of my life and any anguish in their final years.

I continued going to counselling as part of my self-care routine and shared my inability to cry. I remembered when my niece gave me a card in appreciation of something I did for her. It was so meaningful to me, and I wanted to cry but fought back the one tear that welled up in my eye. In a cutting joke, her sister said, "Careful, you may crack a tear, auntie." At that moment, I realized how emotionally unavailable I was and how it affected people close to me.

One day in a counselling session, I recounted being ridiculed by my abuser for crying during an emotional children's show. I shared how crying during movies triggers me, and when my daughter was young, I snapped at her for selecting a movie about a dog dying. Despair instantly swept over me as my heart sunk into my stomach due to my reaction to this innocent child's choice. My guilt was overwhelming, thinking about a potentially moving moment we could have shared, and I ruined it once again. My counsellor suggested that I start letting myself cry. She challenged me to ask myself,

besides the overwhelming discomfort, what would happen if I cried. I knew the answer was that I would be just fine.

So, I set forth on my daunting task of allowing myself to cry instead of suppressing my tears and emotions. One challenge was watching a sad movie, but I couldn't muster up the courage yet. However, I eventually learned to process my trauma by holding my yoga poses longer while allowing myself to cry as I worked through my grief and trauma. As a result, during one of these deeply-held poses, I objectively returned to my teen years and recalled the long-suppressed memory when I was forced into prostitution by a much older man. It was such an overwhelming realization.

Back in 2017, I chose to view my life as a success story rather than a shame story. However, the above epiphany in 2020 allowed me to finally acknowledge that I was unwillingly brought into the world of prostitution as a minor. I thought about my daughter, who was 18 at the time, and I experienced genuine empathy for myself for the first time. I could not imagine my kids or anyone else's child having to run for their lives at that age.

A friend who lived a sheltered life asked me how I knew what to do the first time I turned a trick. I had to think back to that moment, and although it was a vague memory, I remembered not knowing what to do. The man involved was probably in his forties, and when he realized my inexperience, he coached me through the process. He wasn't concerned about my age and didn't question if I was being forced. I know I feared the possibility of being prosecuted for something that I didn't want to do in the first place—this reaffirmed my belief that the police were the enemy. By the shocked look on my friend's face, I don't think it was the answer she was expecting. This conversation initiated the first time I thought about how

little help there was for girls in the nineties and how there is still not enough for those being trafficked today.

COVID-19 restrictions were still in place, and I continued to practice yoga at home and work on my unresolved deeply-buried memories. With some long-forgotten experiences surfacing, I could no longer leave my trauma and past behind. Then, on top of everything I was processing, the burial location of 215 children was being identified at the Kamloops Indian Residential School, and I cried. For months, I grappled with the image of children dying in a school and then buried in unmarked graves. I became even more aware of what these children suffered, given the lack of dignity their small bodies received. I thought about my father and how he never spoke about his experience attending that school. He only shared that there were too many kids to feed, so they often went without food. I now realize that he did what I had been doing for so long; he blocked the extent of his reality and only focused on this one piece. Back then, I was baffled and argued that he was skilled at hunting pheasants at the age of eight, so he could feed himself.

I hoped his experience wasn't as terrible as the stories I heard while imagining my children being ripped from their home and beaten for speaking their language, which would be English today. I thought about my son able to see his sister across the hall yet not able to communicate with her for fear of being harmed. I was plagued by these horrific thoughts every day for months as I mourned the lost children, their lost innocence, and their traumatized families—I wept uncontrollably at a moment's notice.

During one of my yoga practices, I realized that my childhood abuser attended the school where these horrendous acts occurred. Holding my pose, I had overwhelming

compassion for him. Somewhat indescribable, it was like a rush of water washed over me, releasing a lifetime of resentment, anger, and confusion. For the first time, I understood why I needed to forgive him. It wasn't even difficult. Nor was it a process. It was just there—a strong desire to forgive and let go. And I did; I released it from the core of my being.

I knew what I was experiencing was not about absolving a person for their crimes but instead about my willingness and ability to let go. I was finally in a place of peace and didn't regret not finding it sooner. I have been asked many times if I would live my life differently if given a chance, and I responded that I couldn't. I didn't have the peace in my heart to make different choices. I processed so much trauma in such a short time that I often found myself in tears. It wasn't painful, but I teared up easily, and I wondered if allowing myself to cry opened a floodgate of tears bottled up for almost forty years.

From there, I recognized that I had to fight my battle of overwhelming self-doubt. I knew that the conflict with my boss prior to leaving my job left me questioning my accomplishments and qualifications. Because yoga was part of my commitment to self-care, I tried to figure out how to fulfill my desire to make teaching a career decision. Teaching yoga for someone else does not provide a significant income, so I knew I couldn't focus solely on doing that full-time without opening a studio. However, I needed more time to commit to that endeavour and found myself stuck on my next steps for work. So, I continued with my plan to teach yoga when I was able, including private classes and groups and chair yoga at a retirement resort.

While investigating new career opportunities, a wave of defeat came over me, and although I wasn't clear about what was next, I knew it was time to start reaching out to my network.

So, I got uncomfortable and went through my contacts. Networking required effort at this time because COVID-19 prohibited hosting in-person events. Since the pandemic hit, I had to connect with people individually since I could no longer attend an event to network with groups. This required extra time but also inspired more meaningful conversations, which I enjoyed. We shared the challenges we faced with kids and work and how we missed having fun. During one of my calls, a contract came up to write grants, and I decided to take the job because my savings were dwindling and I was good at what was required. This was the start of some wins, and thanks to the man who hired me, I slowly began to rebuild my confidence. With each job, a new opportunity arose, and before I knew it, I was super busy with work again.

I became aware that I garner self-worth by contributing through my work, and I was glad to be busy again, helping communities create opportunities through increased funding. I truly valued working and hired a coach to support me since I still didn't know what I wanted to do long-term. As part of the program, I made some goals, and when I checked my list a year later, I realized that I had met my intention to get back into politics.

I ran for a position on band council, even though I was conflicted because, with my eye on an upcoming municipal election, I was also committed to serving my reserve. An elder in my family called and told me that I had a responsibility to run because I was capable and knew the job. So, I agreed to do it. I decided that if I won, it was where I needed to be; if I lost, I could run in the city election. I worked all day at my consulting job and all night on my campaign, with no time to call people or visit homes, which is the most effective way to campaign. However, I did my best to reach as many people as

possible through social media. Unfortunately, when the voting day came, I didn't get in.

Then, during a sad turn of events, my cousin passed away. She had held a seat on the local school board, so a by-election was called to fill the seat for the rest of the term. I had no intention of running for the seat but received a call asking me to do so. I declined because I was already volunteering for the BC Winter Games and was concerned about overextending myself. It was more important for me to keep my eye on running in the city elections, and I knew it would be difficult to simultaneously hold the board position and run a new campaign. Just the thought of it made me tired.

However, on the day the nominations were closing, I received a call from a local professional, insisting I run in the election, and yet, I still refused. He suddenly became abrupt, telling me a youth was being sex trafficked, and the only person they trusted was an elementary school principal. Knowing that the school system impacts youth, he pleaded with the importance of me holding a seat at the table because of my similar experience. How could I say no? I agreed to run.

It wasn't an easy endeavour, given I was still exhausted from the last election and was working long hours. A friend called and asked what I was doing to get elected. I had to admit I didn't know much about the local election process and had no plan since it was grant-writing season and I was working 12-hour days. He whipped me into shape, urging me to get a team together, and I invited some of the most amazing people I knew to work with me. Despite their busy schedules, they stepped up to the plate and helped me. I was elected!

The election was right before summer began, so I only had two meetings until they concluded until September. It was strange to start a job and then take a two-month break. When

people asked how it was going, I jokingly told them it was the easiest job ever! Then, when we resumed our meetings in the fall, I found that I enjoyed working with the board and was grateful for the experience and the people I met. I also knew that it can be risky joining a board because sometimes they are dysfunctional, leaving little time for productivity; I was grateful this was not the case. However, I spent my spare time catching up on information and reading agendas that were hundreds of pages long.

Then, the 2021 White Rock Lake wildfire ravaged the area, which was surreal to witness. It was an emotional event, watching my family and people I have known all my life flee from their homes as the monstrous fire continued to flourish. I was impressed with the band members running the Emergency Operations Center (EOC) and the Emergency Support Services (ESS) center as they worked endless hours, supporting people in our community while also facing the possibility of losing their homes. I couldn't help but hold a great sense of pride as I watched them work tirelessly through an extremely stressful time. I decided to volunteer for my reserve community's ESS between my other responsibilities.

For weeks, our community waited for the fire to get under control, and I was deeply moved, watching strangers and people I knew enter the ESS center only to be evacuated and sent to neighbouring cities. Many were elderly and had to choose between driving to the next city in the middle of the night or getting on a bus and leaving behind the few cherished possessions they had in a parking lot. I often sat and listened to them express their frustrations, especially about having to be sent to leave their hometown.

I went home and cried for everyone whose houses were at risk. These dwellings held generations of memories that were at

risk of being swept away in an instant. I lived in town, and my family was placed on evacuation alert only once. And although our situation seemed inconceivable, we understood the possible reality since seeing the entire village of Lytton decimated by a different wildfire earlier in the season. So, we had emergency bags packed and ready to go, and everyone was on high alert while seeking updates and watching websites, attempting to determine the risk level we were facing. There was an apocalyptic aura as the smoke blanketed the sky and the mid-summer days remained dark. I tried to support as many people as much as I could through the evacuation process, but it never seemed like I was doing enough. I desperately wanted to bring them to my house, but I didn't have the extra space.

The fire burned out of control and destroyed homes and businesses; thankfully, no one died. The executive director at the band office asked me to fill the recovery manager role. I didn't even know it existed, but I learned that emergency management is an industry in its infancy, and there were few recovery managers available. So, I sat in the EOC for the first two weeks of this role with another team member I just met. They briefed me on response efforts, and we then transitioned from the response phase to the recovery phase.

For the second time in my life, I asked myself, "What have I done!" The first was when I sat through my first council meeting in 2005. This time, I spent 12 hours during each of those 14 days in the EOC, gathering information and learning about all the supporting agencies. Every time I turned around, there was another meeting or videoconference call where I met representatives from the province of British Columbia and Indigenous Services Canada, as well as many other agencies. Some days, I walked into the building and was told I was late for a meeting that I didn't even know about. It was overwhelming.

The Emergency Operations Centre eventually shut down, and the recovery team took over; we were responsible for environmental cleanup, removal of burnt trees, emergency service provisions for those who lost their homes, rebuilding destroyed houses, and financially managing all the projects. I was extremely grateful for my team every day as we worked together to rebuild the community. We are currently still in the rebuilding phase after working diligently for over 16 months with minimal breaks.

My old behaviours began creeping back up on me—the subtle addiction signs of being a workaholic that go unnoticed by many, even when displayed right before their eyes. My health goals quickly slipped away with the added responsibilities I agreed to. The demands of the recovery project were consuming my life, and I was not eating healthy and often eating late. My yoga practice took a back seat due to my heavy workload, and I wasn't walking as much, if at all. Once again, I immersed myself in my workaholic pattern, which allowed me to avoid my emotions by getting buried in projects. Incredibly, my back was holding up, even though I was working 10 to 12-hour days. This reiterated that my last two years of rehabilitation work had paid off.

The demands for my time between the recovery work, the school board, and the BC Winter Games were high, and I had to stay on top of everything. And as if I didn't have enough to do, I decided to take my master's certificate in Project Management (MCPM); some days, I was on my computer until midnight. Everyone thought I was crazy, but I was convinced it was time that I furthered my education. I had my eye on this training for almost five years, but it was now available online due to COVID-19, which meant avoiding a five-hour drive each way twice a month. My desire to do this training was greater than

my need for rest, and it looked like it was the last-planned online session, so I went for it.

Almost immediately after signing up to volunteer and just over a month before the scheduled event, the BC Winter Games were postponed due to COVID-19. It was devastating news for athletes and volunteers alike after having invested a lot of time and energy over the previous year and for some longer. However, I was relieved I had more time to work on my course. Advancing my education was the right decision for me, but I may not have been realistic about my capacity. I became ill with COVID-19 and missed a couple of modules, which was equivalent to missing a month of classes. Unfortunately, I also had to wait to make up these classes in early 2023 and reschedule my final.

However, I accomplished what I set out to do, and succeeding at each of these roles helped me regain the confidence I recently lost—I quickly realized I had a lot more project-management knowledge than I had accredited myself with. The MCPM course helped confirm this belief when I initially thought I would struggle but discovered that I understood the program in some areas and learned new tools in others. By serving on the school board, I became aware of how strong my governance knowledge was and that we were making a difference.

My self-worth returned as I stepped back into myself. Reflecting on experiencing a lot of conflict while working with my boss in my old job, I wondered how I let myself get so caught up in negativity and allowed it to affect my self-esteem. At the time, I wanted to be angry but instead looked at my accountability in the situation and took responsibility for my part within our situation. When it came down to it, I eventually discovered why things happened, so I could accept them as learning experiences and move on. My lesson was that I had

to choose to end the relationship, thus valuing my self-worth. Complaining was neither changing the situation nor providing solutions.

During this reflection about being decisive versus indecisive, I was baffled about how I could confidently make decisions at work but struggled with the same in my personal life. I realized I needed to stop giving energy to those who disrespected me and sat down to evaluate all my relationships. Interestingly, I found there were people in my life with whom I was guarded and couldn't be vulnerable around. Some were conditional with me, and even though loyalty is important to me, being given unconditional love is part of the equation. So, I began being mindful of the people I could share my emotions and be one hundred percent honest with, compared to those I didn't trust with intimate conversations—this awareness allowed me to easily determine who was providing me with unconditional love versus conditional love.

As I continued my inner work, I thought about how most young indigenous cousins grow up being friends. It is unconditional love, and I sought the same within relationships off the reserve. However, regardless of their origin, I discovered that not everyone has the same degree of social intelligence— the self-awareness about how their behaviour and what they say can positively or negatively affect others. I recognized that people are able to learn to be mindful about how they respond to others, understanding that their choice carries either healing benefits or harmful consequences. Nevertheless, as I simultaneously wrote my memoirs and planned to run for the upcoming election, I slowly began sharing my story while authoring my book. Knowing my past, one of my friends expressed his concern about this becoming an issue politically. However, I didn't fear being honest, accountable, or having

conversations about how much I've grown since going to treatment over 20 years ago. I knew I couldn't let the person I was back then stop me from being the person I am today. My biggest concern was, and always is, the possible negative impact openly telling my story might have on my children; I was never concerned about myself. From the start, I was honest about my struggles with addiction, and while not everything can be an open book, I was ready to admit my wrongs.

I adapted many behaviours due to my PTSD, like moving to a new house when too many people found out where I lived. My paranoia was immense as I dragged my children from home to home. When they reached their late teens, I explained why I had this urge to move, subjecting them to my nomadic lifestyle. I was ashamed of this out-of-control need to move constantly, yet I found that it was balanced by the comfort of setting up new homes. I have attempted to maintain stability for me and my children over the last decade, and I am getting better at staying in one place. I know this is just one of a few developed behaviours that I will spend many more years managing, and I am okay with that, giving myself the patience and compassion that I afford others.

Over the years, I learned there are a lot of supportive practices: being honest, responsible, grateful, of service, and forgiving of self and others. However, while each is powerful, nothing is as effective as rest and organization. For example, the less sleep I get, the more my obsessive-compulsive disorder (OCD) exposes itself. While drinking in the 90s, there were times when I had to go back into the house multiple times to make sure everything was off and unplugged. It was maddening to the point that my roommate yelled at me, "If it's going to burn, it's going to fucking burn—let's go!" That statement was oddly consoling when I realized I had no control, and it didn't

matter if it did. I didn't own much at the time anyway, so it didn't make sense that I was so worried.

No longer struggling with substance abuse, my OCD transitioned into habits like cleaning, which resulted in the sheet-washing incident when I fell down the stairs. I was so tired that I could barely stand, but I couldn't leave it for a day. Hoping to prevent future injuries, I have since adopted the attitude of "It will be there tomorrow." Prior to that incident, I often found myself weeding the landscaping rocks, obsessed with removing every blade of grass to achieve perfection, even though I was in a state of exhaustion.

My life can become chaotic, so I need to be organized to be efficient and have everything operate as optimally as possible. While my OCD is not debilitating, I become out of control when it surfaces, ironically, trying to gain control and maintain perfection. For example, when I injured my back during my fall, I noticed that I functioned much better after a solid night's sleep, and it supported me in so many areas of my life. Alternatively, I also resented the time I felt I was wasting sleeping.

That soon changed as the municipal elections approached and I confirmed giving up my seat on the school board to make space to run for city council. Running a campaign and working, the long hours were tough, but I knew what it entailed, and I had a team of amazing friends who supported me. I worked hard and gave one hundred percent to my campaign.

I was writing this book at the same time and not sleeping much. Not wanting to give up, I continued to write, which attributed to more sleep deprivation. I became quite emotional with no time to process the trauma that came up. I finally had to set the writing aside when I found myself writing about me and Jimmy dreaming about our future—I spent the day in bed

bawling my eyes out because I still missed him so much. I was still grief-stricken that our dreams remained unrealized, and I made a commitment in his memory to fulfill our vision of having that big, beautiful house.

Memories of Jimmy flowed to memories of friends lost to suicide, HIV, overdoses, and the painful reality that most people I grew up with outside of high school were dead. My emotions took over as I tried to focus on my political career, and then, I realized I was dealing with too much. My writing coach/editor called it, deciding to revamp the timelines so I could concentrate on my campaign. She knew I couldn't do that while honouring the process of writing that included reliving painful stories, recalling good memories of people I once cared about, even though they were gone, and processing the grief of their loss. Because one of my mechanisms was to block memories, I needed to go into a trance-like state to go back to my darkest moments to find the words to write. There were many times I couldn't go on and had to stop to cry for my lost childhood.

Close to election day, turmoil ensued as a rumour of ambiguity spread surrounding which candidates I supported. Some said that I shared a campaign manager with one of them because my good friend, campaign manager, and one of my most trusted confidants supported a candidate who wasn't popular in some circles. We had a conversation, and she suggested that I not include her in my team photos. She was worried that her presence in the picture would be questioned. I knew I should listen to my campaign manager's advice, but honouring my values was more important to me than getting votes—she was by my side daily, either working with me or helping with signs, even though she was a business owner and had a demanding life. Perhaps this isn't an expected approach

to politics, but I wanted to recognize my team for all their work. Ultimately, I lost the election, but not for lack of trying. I lost by only 286 votes, which is great for a rookie! I couldn't have done it without the support of my team, friends, and family. In the background, my counsellor kept me sane, my writing coach/editor provided guidance, and my book-development-program coach lent an ear. The loss was disappointing, but I was still happy with the results because I was so close! When I returned to writing my book, I realized I was having trouble being honest while sharing my story. During the election, I was concerned about how people would react to my history. I didn't realize that I was subconsciously holding back my truth. However, once the election ended and I resumed my writing and editing process, I realized I was censoring myself. I was saddened that I was not writing the book I wanted to write. Ironically, I watched a movie around this time, and one of the characters told a writer to write as if no one would read what they put on paper. I took that advice, and even though it was just a line in a movie, I wrote my authentic story from that moment on.

Today, when asked if I plan on running in the next election, I laugh and say, "We will see what happens after I release my book because it can go either way." From the beginning, there were moments when I grappled with being honest as I sought clarity about my reality. Then, I had to put aside what I was worried might happen and just do the work. My goal has always been to simply tell my narrative to reach those who may be suffering in silence and let them know they are not alone. Maybe my life story will inspire victims of human trafficking to reframe their shame story into one of success—the empowerment of freedom provides the hope that tomorrow can be different.

The reality is that I was fortunate I had family who supported and accepted me throughout my healing journey. Today, I am a professional, working hard to maintain not only a high level of emotional intelligence but also strong social intelligence whereby I mindfully reflect on how my actions affect myself and others. Today, I work hard at holding myself to a higher standard, and while I don't strive for perfection, my goal is to build a better life for myself and my family. I made mistakes, but when I walked through those doors at the treatment center on June 3, 1999, I accomplished more positive action than I or anyone else could have ever imagined.

I wish I could say I shared every trauma tale I experienced, but I did not—truthfully, there is so much more. I can't help but believe in guardian angels. Maybe some people call it luck or nothing at all, but I know I had someone or something to guide me through my most dangerous times. I don't take my life for granted anymore; I'm pretty sure I've used up most of my nine lives, and I don't care to count how many times I almost died for fear there is only one left. However, I know for sure that I survived what I did so I can go through life with a positive outlook and attitude that inspires others to do the same. I crave spending time with those who want to live with a mindset that builds a better future for themselves. I don't know what tomorrow will bring, but I am grateful for having the clarity about the one thing I want to take with me on my final day: the vision of people building each other up to create internal strength instead of tearing them down.

Now, as you close this book and put it down, I ask one thing—look past a story of pain to the hope that guided me towards achieving the strength I needed to find the lioness within.

I first met Jenelle in the course of my work with Okanagan Nation communities. Despite her strong positions and tough stances through many difficult times, her deep commitment to justice and fairness and her compassion always shone through. The intergenerational effects of colonialism, residential schools, addiction, and abuse continue to ravage the communities, and the struggle to overcome them so often seems hopeless. Countless numbers of our youth succumb to addiction, overdose, and suicide each year. At the same time, this is a story of untold tragedy, abuse, injustice, and suffering in the narrative. In its essence, it is a story of resilience and hope, while remaining human, alive, and caring throughout it all. I cannot imagine the pain Jenelle would have endured to relive all these experiences and the courage required to openly share this story. However, I'm firmly convinced that the value of her doing so will be immense.

Allan Price

About the Author

Jenelle Brewer is an indigenous mother of two adult children. No matter how often she tried to leave, she returned to her family on the reserve in the Syilx territory where she grew up. Jenelle often wonders how others live without the strong connection she has to the land that speaks to her.

This first-time author has been described as vibrant and energetic, always seeking challenging projects. She fearlessly welcomes uncomfortable experiences, knowing they provide opportunities for personal and professional growth. Beneath her tough exterior is a warm and generous heart that passionately supports and advocates for her community while simultaneously making amends for her past.

As a child abuse victim and a woman who fully recovered from drug addiction, Jenelle advocates for others to understand that trauma is an underlying cause of addictions. She continues to support trauma survivors using the power of love and tirelessly shares her message that they are not alone.